A Miscellany of
ARTISTS' WISDOM

A Miscellany of

ARTISTS'
WISDOM

Diana Craig

RUNNING PRESS
Philadelphia, Pennsylvania

Canadian representatives: General Publishing Co., Ltd.,
30 Lesmill Road, Don Mills, Ontario M3B 2T6.
International representatives: Worldwide Media Services, Inc.,
30, Montgomery Street, Jersey City, New Jersey 07302.

9 8 7 6 5 4 3 2 1
Digit on the right indicates the number of this printing.

Library of Congress Catalog Number 92-50810

ISBN 1-56138-253-1

A Miscellany of Artists' Wisdom
Compiled by Diana Craig
Consultant Laurence Wood
Designed & arranged by Simon Jennings
Edited by Peter Leek
Illustrations & engravings enhanced by Robin Harris

Produced, edited, and designed by Inklink,
Greenwich, London, England
Published in the United States by Running Press,
Philadelphia, Pennsylvania
Typeset in Garamond by Inklink
Printed in Hong Kong by South Sea International Press

This book may be ordered by mail from the publisher.
Please add $2.50 for postage and handling.
But try your bookstore first!
Running Press Book Publishers
125 South Twenty-second Street
Philadelphia, Pennsylvania 19103

A MISCELLANY OF

ARTISTS' WISDOM

TABLE OF

CONTENTS

ARRANGED IN SIX CHAPTERS

Ars longa, vita brevis
("Art is long, life is short")

THE URGE TO PAINT, *to make marks on a flat surface that represent the visible world, is as old as human time itself. The painter William de Kooning once talked about a train track running through the history of art, spanning the millennia and linking all the artists along the way. Following this track, the caveman or cavewoman painting animals on the rough stone of cave walls eventually becomes the eighteenth-century watercolorist, who in turn becomes the twentieth-century abstract painter. Styles and schools may come and go, but the human animal will always remain an artist.*

In this book, I have looked at art both as the supremely skilled craft it once was and as "high art," the product of inspired genius. In earlier times, artists had to serve their apprenticeship and learn the techniques of their trade, in the same way as other craftspeople. It is fascinating to delve into early artist's handbooks, such as Cennino Cennini's famous IL LIBRO DELL'ARTE, and discover just how much an artist had to learn before so much as lifting a paintbrush. But the old notion of art as craft gradually slipped away, to be replaced by the idea of art as concept. With the development of commercially produced materials, the artist was liberated from the labor of mixing paints or binding animal hair into brushes. The advent of photography had an impact too, since it offered a new means of representation.

To give an idea of what it means to be an artist, I have included some anecdotes of the ups and downs of artists' lives – such as the struggle to complete a commission on time or get properly paid, and, transcending all such concerns, the passion for art itself. Some of these stories are amusing, many are informative, and some of them are profoundly moving.

DIANA CRAIG

DEDICATED TO ALL
OF INVENTIVE MIND
AND GRACE OF HAND

CHAPTER ONE:
THE DELIGHTS OF DRAWING

*"GOOD SKETCHES BY GREAT MASTERS ... ARE USUALLY THE
START OF AN ENTHUSIASM FOR ART AND SLOWLY LEAD THE
AMATEUR TO THE THRESHOLD OF THE WHOLE OF ITS WORLD,
FROM WHICH, IF HE ONCE LOOKS ONWARD, HE WILL
NEVER TURN BACK."*

FROM PROPYLAEN BY JOHANN WOLFGANG VON GOETHE, 1799

THE SKETCHBOOK

Just as dancers and musicians need regular practice to maintain standards, so regular drawing, preferably on a daily basis, greatly improves the artist's skills and vision. A sketchbook is invaluable for this purpose and can be used for recording impressions, experimenting with ideas, and perfecting your drawing skills. If it is a convenient size, then you can carry it around with you and instantly record anything that catches your eye. It's important, however, not to be too concerned with the finish of your sketches – the importance of a sketch lies in its spontaneity. It is a direct response to what is seen, and is not meant to be a finished work.

"Sketches... are in artists' language a sort of first drawing made to find out the manner of the pose, and the first composition of the work. They are made in the form of a blotch, and are put down by us only as a rough draft of the whole. Out of the artist's impetuous mood they are hastily thrown off, with pen or other drawing instrument or with charcoal, only to test the spirit of that which occurs to him."
From LIVES OF THE ARTISTS by GIORGIO VASARI, 1568

"Why does a fine sketch please us more than a fine picture? It is because there is more life in it and fewer forms... Why can a young student, incapable of doing even a mediocre picture, do a marvellous sketch? It is because the sketch is the product of enthusiasm and inspiration, while the picture is the product of labour, patience, lengthy study and consummate experience in art."
From THE SALON OF 1767 by DENIS DIDEROT

PRACTICE MAKES PERFECT

"Set yourself to practise drawing, drawing only a little each day, so that you may not come to lose your taste for it, or get tired of it… Do not fail, as you go on, to draw something every day, for no matter how little it is, it will be well worth while, and will do you a world of good."
From IL LIBRO DELL'ARTE by CENNINO CENNINI, c. 1435

"He [Ingres] said to Monsieur Degas: 'Draw lines, many lines, from memory or nature: it is by this that you will become a good artist.'"
From THÉORIES: LA DOCTRINE D'INGRES by MAURICE DENIS, 1912

DRAWING SKILLS

Pope Benedict IX wanted to commission some paintings for St Peter's in Rome, and accordingly sent a messenger to the painter Giotto to report on what the artist's work was like. On being asked to produce a drawing to take back to His Holiness, Giotto took a piece of paper, pressed his arm into his side to hold it steady, and, with a quick twist of his wrist, painted the most perfect circle on the paper: "See if this is understood," he said.

The messenger, feeling that he had been made a fool of, nevertheless took the drawing back with him. When he showed it to the Pope and explained how such a perfect circle had been drawn without moving his arm and without a compass, the Pope and all those present acknowledged Giotto to be the most skilled artist of his time.

DRAWING IMPLEMENTS

*"The Instruments of Drawing are Sevenfold, viz.
Charcoals, Feathers of a Duck's Wing, Black and Red
Lead Pencils, Pens made of a Raven's Quills, Rulers,
Compasses, Pastils and Crions [Crayons]."*
From POLYGRAPHICE by WILLIAM SALMON, 1672

CHARCOAL

The use of charcoal as a drawing medium goes back
to prehistoric days. At some momentous point in time
prehistoric man discovered that little pieces of charred
wood from the fire could be used to make marks on
stone or draw the outlines of animals on cave walls,
and so the earliest works of art were born. The
charcoal we use today is made from vine and willow
twigs, and differs little in its nature from the medium
used by the first artists thousands of years ago.

HOW TO MAKE CHARCOAL

*"Take a nice, dry, willow stick; and make some little
slips of it the length of the palm of your hand, or, say,
four fingers. Then divide these pieces like match sticks;
and do them up like a bunch of matches. But first
smooth them and sharpen them at each end, like
spindles. Then tie them up in bunches this way, in three
places to the bunch, that is, in the middle and at each
end, with a thin copper or iron wire. Then take a
brand-new casserole, and put in enough of them to fill
up the casserole. Then get a lid to cover it, luting
[sealing] it with clay, so that nothing can evaporate from
it in any way. Then go to the baker's in the evening,
after he has stopped work, and put this casserole into the
oven; and let it stay there until morning."*
From IL LIBRO DELL'ARTE by CENNINO CENNINI, c.1435

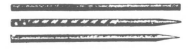

DRAWING WITH CHARCOAL

The charcoal should first be sharpened to a point. To enable the artist to stand a distance from the work in order to judge it, the charcoal may be tied to a little stick or cane. Any mistakes may be erased by brushing the charcoal with a feather. When the artist is happy with the drawing, he should go over the outlines with a silver stylus; the drawing should then again be brushed with the feather to remove any remaining charcoal marks. The final result will be a drawing "fixed" by the silver stylus.

COLORED CHALKS

Naturally found drawing materials, such as chalk and other soft stones, may be among the oldest artist's materials known to man. Their great appeal is that they can be used almost in their natural state, requiring no complicated manufacturing processes and little preparation. Writing in the fifteenth century, Cennino Cennini speaks of a black stone from Piedmont in Italy that was dense in color and soft enough to be sharpened with a knife. Vasari mentions a black chalk from the hills of France, and a soft red chalk from the mountains of Germany.

SILVERPOINT

Until the invention of the pencil, the silver stylus was one of the most common drawing materials. The silver tip made a light gray line that gradually became tarnished and deeper in color as it was exposed to the air. As an alternative to silver, lead, copper, and sometimes even gold were used. In order to have the necessary "tooth" – or surface texture – to hold the tiny granules of silver, the drawing surface had to be coated with size or gesso.

SIZE A solution of glue, gum, or resin.
GESSO A mixture of the mineral gypsum
(the source of plaster of Paris) and glue size.

INK

In early medieval times, the production of ink must have been a messy business. The most satisfactory black ink was derived from ground charcoal made from grape vines; another ink was made from the boiled soot of hawthorn wood. So-called "Indian ink" was in fact Chinese, and reached Europe in the late seventeenth century.

"Indian or Chinese Ink is sold, like our mineral colours, though much lighter; it is usually of a rectangular figure, about a quarter of an inch thick, being cast in little wooden moulds. It is ground in a little hollow marble or stone with water in it, till the water becomes a sufficient blackness. It makes a very black shining Ink which, though it sink when the paper is thin, never runs. It is of great use in designing.

The Chinese make it with smoke-black of different kinds, the best is the smoke of fat pork burnt in a lamp. They mix a kind of oil to make it smooth, and other odoriferous ingredients to take away the rank smell."
From THE DICTIONARY OF ARTS AND SCIENCES, 1754

THE EGYPTIAN METHOD

In ancient Egypt, a red ink or pigment was generally used for the initial drawing, which would then be finished in black. The ivory palettes used by artists and scribes had two little wells for the red and black pigments, and compartments for holding reed brushes.

THE PEN

The word "pen" comes from the Latin word for feather – and before the invention of steel-nibbed pens, which became available in the early nineteenth century, pens were generally made from feathers or "quills." Geese, woodgrouse, ravens, and swans were all popular sources of quills – the best ones being shed naturally, since plucked quills did not have time to "ripen" to the necessary hardness. Cutting the quill into shape was a tricky business, and had to be suited to the hand of the individual user. The natural oils also had to be removed if the pen was to hold ink.

"Good quills and a sharp knife are the first things necessary. Quills that grow on the left wing will better conform to the hand [of a right-handed person] than those on the opposite."

From AN ANALYTICAL GUIDE TO THE ART OF PENMANSHIP by ENOCH NOYES, 1823

HOW TO CUT A QUILL PEN

"Get a good, firm quill, and take it, upside down, straight across the two fingers of your left hand; and get a very nice sharp penknife, and make a horizontal cut one finger along the quill; and cut it by drawing the knife toward you, taking care that the cut runs even and through the middle of the quill. And then put the knife back on one of the edges of this quill, say on the left side, which faces you, and pare it, and taper it off toward the point. And cut the other side to the same curve, and bring it down to the same point. Then turn the pen around the other side up, and lay it over your left thumb nail; and carefully, bit by bit, pare and cut that little tip; and make the shape broad and fine, whichever you want, either for drawing or for writing."

From IL LIBRO DELL'ARTE by CENNINO CENNINI, c.1435

CROSSHATCHING

The technique of crosshatching, still used in pen-and-ink drawing and in certain kinds of printmaking, was developed by early silverpoint artists such as Albrecht Dürer and Leonardo da Vinci. The problem facing these artists was how to create areas of tone and shadow in a medium that produced only lines. They discovered that drawing a network of fine parallel lines, criss-crossing each other, created an illusion of shadow when seen from a distance. By varying the weight of the lines, darker or lighter tones could be achieved.

PEN LINES

The type of line produced by a pen depends on the nib used and the pressure exerted on it:

THE SLIP NIB gives a fluid, even line.

THE MAPPING NIB produces an even line that can be either fine or heavy, depending on the amount of pressure exerted.

THE CROW QUILL has a fairly rigid nib, so the weight of the line cannot be varied greatly by applying pressure.

THE ITALIC NIB produces an angular line of alternate thick and thin strokes.

THE SCRIPT NIB produces a similar effect to the italic nib, but the angles of the strokes are more rounded.

THE COPPERPLATE NIB is angled so that it will produce both vertical and horizontal strokes.

THE FIVE-LINE NIB produces five parallel lines of equal weight and is particularly useful for crosshatching.

THE PENCIL

The word "pencil" originally meant a paintbrush (see p. 34). The so-called "lead" pencil, as we know it today, did not appear until after the discovery of graphite in Cumberland in the north-west of England in 1504. An earlier find had been made a century before in Bavaria, but it was only after the English discovery that the potential of the mineral as an artist's medium was realized. Graphite was at first thought to be a form of lead, hence the term "lead" pencil. "Cumberland pencils" and "crayons d'Angleterre" (English pencils) were other early names for the new drawing implements. The chief source of graphite was the Black Comb Hill mine, and the strange new use for the mineral was noted by the deputy governor of the royal mines in 1683:

"Black Lead… of late… is curiously formed into cases of Deal or Cedar."

GRADES OF PENCIL

Nowadays pencils vary in hardness and therefore density of blackness, but such variations were not developed until the 1790s. Owing to lack of graphite supplies from the English mines, a French chemist, Nicolas-Jacques Conté, began experimenting to see whether existing stocks of graphite could be made to go further. He discovered that graphite could be ground with clay and fired in a kiln, and that adding more clay produced a harder pencil.

To indicate their hardness or softness, pencils are given codes. These range from the very hard 8H (which gives a thin light-gray line) to the very soft 8B (which gives a smudgy densely black line). The artist needs to have a range of pencils available in order to be able to produce different effects.

PASTELS

These soft coloring sticks are called pastels because the colors are made from a paste of powdered pigment bound with weak gum or resin. Pastels come in three qualities – soft, medium, and hard. Oil pastels are more firmly bound than ordinary pastels, and so are harder. When drawing with pastels, the paper should be held at an angle so that excess dust can be tapped or blown off.

KEEPING PASTELS SHARP
Ordinary pastels can be brought to a point by rubbing them gently on a piece of fine sandpaper. Oil pastels are firm enough to be sharpened with a knife.

MIXING PASTELS
To "mix" pastels, different colors may be laid over each other and blended by smudging gently with a finger. An interesting effect can also be achieved by drawing short lines in one color over a ground in another color: seen from a distance, the colors will "blend" to create a different hue.

HIGHLIGHTS
Pastel can be "lifted" to create highlights or lighter tones, using either a putty rubber kneaded to a point or a soft sable brush.

FIXING PASTELS
Pastel drawings may be fixed to protect them, using either a fast-drying commercially produced fixative or one made at home from 2 parts dammar varnish to 98 parts benzine. The fixative can be applied with a bulb-and-nozzle sprayer or a mouth atomizer, kept specially for the purpose. To ensure an even coating, begin by spraying into the air then guide the spray across the paper and out into the air again.

The disadvantage of fixing pastel is that it can affect the brilliance of the colors. Possibly in order to overcome this problem, the French Impressionist painter Edgar Degas used to fix each layer of his pastel drawings except for the final layer, which he left unfixed.

MAKING YOUR OWN PASTELS

Making your own pastels is not only cheaper than buy-
ing them; it also enables you to achieve the exact tints
you require.

Begin by making a binding solution of 1oz of
powdered tragacanth mixed with $1^{3}/_{4}$ pints of distilled
water. Leave this to stand in a warm place overnight.
Shake out your chosen pigment onto a thick piece of
glass. Using a palette knife, mix it to a paste with some
of the binding solution.

Shape the pastel crayon by rolling the paste between
a sheet of absorbent paper and a sheet of cardboard
covered with more absorbent paper. Before using it,
leave the crayon to dry for 24 to 48 hours.

THE ARTFUL SMUDGE

Artists of old learned to turn the inadvertent smudge to
good advantage, making it an intrinsic part of the
drawing. To help achieve subtle blending of tone, they
used a tool called a stump or tortillon, which consisted
of chamois leather, blotting paper or a fungus known as
amadou tightly rolled and sharpened at both ends – an
ancient equivalent, perhaps, of the cotton bud.

FIXING A DRAWING

Soft drawing materials such as charcoal smudge easily,
and it is only comparatively recently that special fix-
atives have been available. In Renaissance times, artists
were advised to "fix" charcoal drawings by going over
them with ink or a silver stylus. The charcoal under-
drawing could then be brushed away with a feather.
Drawings could also be fixed with skimmed milk.

SURFACES FOR DRAWING

Nowadays we automatically think of using paper when it comes to drawing – but before paper was invented, artists had to use other surfaces.

WOODEN PANELS
Wood is one of the most ancient surfaces for drawing and painting. Various woods were considered suitable, the choice depending on local availability. In Italy, box and fig were recommended for small panels; lime, willow or poplar for larger ones. Oak was popular in Flanders, the Netherlands, northern France, and Britain. In southern Germany artists favored lime or fir, while the Russians preferred lime.

PAPYRUS
As well as wooden panels and limestone flakes known as *ostraca*, the ancient Egyptians favored papyrus as a surface for drawing and writing. Papyrus was made from the pulp of the reed of the same name, and was widely used until supplies of the reed began to run out.

PARCHMENT
This popular, if expensive, drawing surface replaced papyrus. It was made from the treated skins of certain mammals – most commonly sheep. Parchment made from calf skin was known as vellum. The preparation of parchment was a laborious process. The stretched skin had to be washed, then dried in the sun, at least three times; after this it would be gessoed and coated with powdered white lead mixed with linseed oil, each coat in turn having to be dried in the sun.

LINEN
A cloth known as architect's linen, made from cotton and treated with starch, was much used for technical drawings in the nineteenth and early twentieth centuries. Leonardo da Vinci apparently used a similar surface, known as Rheims cloth, for his drawings.

ERASING ERRORS

If drawing with a leaden stylus – the ancient equivalent of the modern lead pencil – mistakes could be erased by rubbing the surface with a little freshly baked rye bread. The part of the loaf used was the soft inside crumb, kneaded to a putty-like consistency. A cuttlebone or a bundle of leather strips called "dolage" could also be used for erasing errors. When working with charcoal, unwanted marks were brushed away with a goose's or chicken's feather.

PREPARING A WOODEN PANEL FOR DRAWING

Wooden panels used for drawing had to be prepared by coating the surface with a mixture of ground bone. Old fig wood was considered an admirable timber for panels. The ideal size was about 9in square, and the panel needed to be clean and rubbed smooth with cuttle. The best bones for coating the surface came from the second joints and wings of fowls or capons – the kind you were most likely to find discarded under the dining table after a meal. The thigh or shoulder bones of a gelded lamb were regarded as suitable, too. The older the bones were, the better. The bones were put in the fire and left to turn whiter than ashes. They were then ground for about two hours on a slab of porphyry to produce a fine powder. This could be kept dry in a little bag until needed, when a small amount could be mixed up with saliva and spread, with the finger, over the panel.

PORPHYRY a hard reddish-purple crystalline stone.

THE ORIGINS OF PAPER

Paper was almost certainly first made in the Far East. The oldest surviving fragment of paper, found in a remote part of China, is believed to have been made around 90 A.D. In the eighth century, Samarkand, Baghdad, and Damascus became important papermaking centers after the Arabs were told how to make paper by Chinese prisoners of war. During the twelfth century, paper was imported into Europe from Constantinople (Istanbul) – it was even popularly known as "Byzantine parchment" – and at the same time it was being made by the Moors in southern Spain. Not long afterwards paper mills were set up in the province of Ancona in Italy; and from Italy its manufacture soon spread throughout the rest of Europe, reaching France in 1248, Switzerland in 1380, and England and the Netherlands around 1450.

THE RIGHT KIND OF PAPER

Paper with a smooth surface, such as cartridge, is suitable for pencil drawing. Generally, the softer the pencil, the smoother the paper should be. On more textured papers, a hard pencil gives a cleaner line.

For pen and ink, choose a hard, smooth paper, such as heavy cartridge of about 60 lbs. Softer, more absorbent papers with a fluffier texture may catch on the nib and tear, and may make the ink spread unevenly.

For pastel work, paper with sufficient tooth is needed to catch the pastel as it is drawn across the surface. Velvety sugar paper and Ingres paper, with its gently ridged surface, are ideal. These papers come in a range of colors – and the color itself can become an integral part of the drawing, being used to create highlights or dramatic contrasts. Like pastels, charcoal needs paper with a strong tooth, and a colored surface can help to emphasize the dense blackness of the medium.

Chapter two:
The Pleasures of Paint

*"A PAINTING, THEN, IS A PLANE COVERED WITH PATCHES OF
COLOUR ON THE SURFACE OF WOOD, WALL, OR CANVAS
FILLING UP THE OUTLINES... WHICH, BY VIRTUE OF A GOOD
DESIGN OF ENCOMPASSING LINES, SURROUND THE FIGURE."*

FROM LIVES OF THE ARTISTS BY GIORGIO VASARI, 1568

THE PLEASURES OF PAINT

Oil Painting Outfit Complete.

27083 Oil Painting Outfit, consisting of extra fine japanned tin box, size,13x9x3 with bevel top; contains 25 tubes of oil colors, assorted, 6 bristle brushes, 4 red sable brushes, 2 Bright's bristle brushes, 1 Badger blender No. 4, 1 bottle each pale drying and poppy oil, and spirits of turpentine, steel palette knife, mahogany palette, 3

THE INVENTION OF OIL PAINTING

"A most beautiful invention and a great convenience to the art of Painting, was the discovery of colouring in oil. The first inventor of it was John of Bruges in Flanders, who sent a panel to Naples to King Alfonso, and to the Duke of Urbino, Federico II, the paintings for his bathroom."

From LIVES OF THE ARTISTS by GIORGIO VASARI, 1568

Vasari's famous contention reproduced above was not entirely true. Oil paint was invented centuries before the time of "John of Bruges" (Jan van Eyck), but originally it was considered suitable for outdoor use only. What van Eyck did accomplish was to make oil paint acceptable as a medium for work that was to be displayed indoors, and to demonstrate the marvelous effects that could be achieved in the medium.

"Colouring in Oyl is the most Perfect and excellent of all others, and has superseded the ancient Practice of Dry Painting."

From THE ART OF PAINTING AFTER THE ITALIAN MANNER by JOHN ELSUM, 1704

TYPES OF OIL

Linseed oil, from the seed of the flax plant, and walnut oil were among the first oil mediums used by artists, although hempseed oil and, later on, poppy oil were also used. Leonardo da Vinci liked to use distilled cyprus oil (a form of turpentine) mixed with juniper gum, but he also used mustard seed pounded and pressed with linseed oil.

HOW TO MAKE LINSEED OIL

Theophilus Presbyter, writing around the twelfth century, provided the following instructions for artists wishing to make their own linseed-oil medium:

"Take linseed and dry it in a pan, without water, on the fire. Put it in a mortar and pound it to a fine powder; then, replacing it in the pan, pour a little water on it and make it quite hot. Afterwards wrap it in a piece of new linen; place it in a press used for extracting the oil of olives, of walnuts, or of the poppy, and express this in the same manner. With this oil grind minium or vermilion, or any other colour you wish, on a stone slab, without water; and with a brush paint over the doors or panels which you wish to redden, and dry them in the sun."

MINIUM A rich vermilion used for the illumination of manuscripts.

SUN-THICKENED OIL

Oil thickened by exposure to heat has less of a tendency to yellow, and so is preferable for oil painting. Stand oil, which is heated to 600°F in a vacuum without oxygen, is the most reliable kind of linseed oil – but, according to Cennino Cennini, a similar result can be achieved by exposing oil to the sun:

"Take your linseed oil, and during the summer put it into a bronze or copper pan, or a basin, and keep it in the sun when August comes. If you keep it there until it is reduced to a half, this will be the most perfect for painting. And know that I have found it in Florence as good and choice as it could be."

From IL LIBRO DELL'ARTE by CENNINO CENNINI, c. 1435

WATERCOLOR

In the eighteenth century English painters excelled at watercolor painting – on paper, vellum, or ivory – to such a degree that it became known as "the English art." Later, in America, a strong tradition grew up in the hands of such exponents as Winslow Homer, Thomas Eakins, and Edward Hopper.

When mixed with water, the colors become transparent. Gouache, an opaque watercolor, has had white incorporated into it.

MAKING UP WATERCOLORS

Modern watercolors are bound with gum arabic, but in medieval times "glair" (white of egg) was the usual medium. A century or two later, watercolor was mixed with gum arabic, gum senegal, size, sugar candy, starch, and isinglass. The purpose of the sugar was to stop the gum arabic making the paint crack. The famous English miniaturist Nicholas Hillyarde described the ideal ingredients:

"... the watter wel chossen or distilled most pure, as the watter distilled frome the watter of some clear spring... the goume to be Goume Arabeeke, of the whitest and briclest [brittlest] broken into whit pouder, on a fair and cleare grinding stone, and whit suger candy in like sort to be keept dry in boxes of Iuory, the grinding stone of fine Cristall, Serpentine, Iasper, or Hard Porfory..."

From A TREATISE CONCERNING THE ART OF LIMNING
by NICHOLAS HILLYARDE (1547-1619)

ISINGLASS A gelatin derived from
the bladder of the sturgeon.

GRINDING PIGMENTS

Being an artist in the old days was hard work: paints were not available ready-made in handy tubes, and had to be mixed from scratch. This involved laborious grinding of the necessary pigments, a job frequently given to apprentices in the studios of the masters. The implements used were a muller (crushing tool) and grinding stone, or sometimes a mortar and pestle. The ideal muller was a "Pebble Stone of the form of an Egg" sliced in half to provide a hard flat surface, while the grinding stones were made of serpentine, marble, or, best of all, porphyry.

Pigments were normally ground with water, and then allowed to dry to a powder for storage. In most cases, the longer a pigment was worked, the better the color.

THE PROBLEM OF DUST

The grinding up of pigments could itself produce another undesirable problem – that of dust. To keep the studio as dust-free as possible, apprentices often ground the color in an adjacent room known as the "color closet." The painter Gerard Dou (1613-75) was so bothered by the idea of dust that he is said to have climbed into his studio through a trapdoor in the ceiling, and then waited 15 minutes or so for the dust to settle before beginning work.

There were other ways, too, to deal with dust. The sixteenth-century English miniaturist Nicholas Hillyarde recommended that:

"Yr aparell be silke, such as sheadeth lest dust or haires … beware yo tuch not yr worke with yr fingers… neither breath one it, especially in could weather, take heed of the dandrawe [dandruff] of the head sheading from the haire, and of speaking ouer yr worke… for the least sparkling of spettel [spittle]."

KNOW YOUR COLORS

Any artist who wishes to produce a professional result is advised to:

"… make himself well acquainted with the qualities and hues of the different pigments in their dry state, that he may judge of the goodness or deficiency of them when ground in oil, it is a pity, but it is true, there are many, and some of much merit, that scarce know the difference of umber and oker in their crude state."

From
ESSAY ON THE MECHANIC
OF OIL COLOURS by
WILLIAM WILLIAMS, 1787

Lustre Paint Bronzes.

For painting on plush, velvet, silk, satin and for ornamental gilding and decorative purposes.
27125 One dozen bottles of bronze, assorted colors; also one bottle medium for mixing with the bronze. Assortment of colors in each box.

SOME ANCIENT COLORS

Many of the colors once commonly used are no longer available. Some had strange origins – and some were dangerous to use, being highly poisonous.

REDS

Sinoper was derived from a natural pigment found originally at Sinope on the Black Sea.

Red lead was made by gently heating yellow massicot (see opposite), but had a tendency to turn black.

Hematite was ground from a stone so hard that it had to be broken up in a bronze mortar before grinding, for fear of cracking the grinding stone.

Vermilion, one of the oldest colors, was originally made from a natural pigment, but even in the time of the ancient Greeks could be produced artificially from sulphur and mercury. When buying it, the buyer was advised to check its purity.

BLUES

Egyptian blue – similar to the modern cobalt blue – was made and used in Egypt for about 2,000 years, until some time between the second and seventh centuries A.D. It was obtained by heating sand, copper carbonate, soda, and lime to extremely high temperatures: but if overheated, the color would turn to green.

Azurite, a lightish blue derived from carbonate of copper, was much used between the fifteenth and seventeenth centuries.

Ultramarine, a rich deep blue still in use today, was originally made from the mineral lapis lazuli. Its preparation was a lengthy and laborious process. Like red hematite, the stone was so hard that it had first to be broken up in a mortar, which was covered with a cloth to prevent the precious dust blowing away. The powder was then mixed into a paste with resin and oil, and left for at least three days. Finally, the color was extracted by kneading the mixture under lye (an alkaline solution of water and wood ashes).

YELLOWS

Orpiment was said to resemble gold more closely than any other color. Unfortunately, however, since it was a derivative of arsenic, it was extremely poisonous. When preparing it, the artist was advised to "beware of soiling your mouth with it, lest you suffer personal injury." Another yellow, *realgar*, was also highly poisonous.

Massicot – a dull pale yellow – was made by roasting metallic or white lead, and was used by Leonardo da Vinci, among others, for painting flesh tones. *Naples yellow* is said to have come from a pigment originally found on Mount Vesuvius.

Indian yellow, once used in watercolor, was prepared from the dried urine of cows fed on mango leaves.

GREENS

Malachite is a very ancient color, used throughout the history of painting, as was *verdigris*. The latter was produced, rather alarmingly, by corroding copper plates in acetic-acid vapor, and was ground in vinegar.

The highly poisonous *emerald green* was derived from arsenic and copper.

EARTH COLORS

Yellow and *red ocher, raw* and *burnt sienna, raw* and *burnt umber, terre verte, Venetian* and *Indian red* are all earth colors, and are some of the oldest pigments known to man. *Burnt sienna* is produced by roasting the raw pigment, named after the Italian city near which it was first found; *burnt umber* is made in a similar way. *Red ocher* and *Venetian* and *Indian reds* can be produced by roasting yellow ocher.

Earth pigments come from clay and other substances in the earth, colored by ferric oxide. Cennino Cennini described the wonder of seeing "colors in the earth":

"And upon reaching a little valley, a very wild steep place, scraping the steep with a spade, I beheld seams of many kinds of colour: ochre, dark and light sinoper, blue, and white; and this I held the greatest wonder in the world – that white could exist in a seam of earth… And these colours showed up in this earth just the way a wrinkle shows in the face of a man or woman."

BROWNS

Traditionally *sepia* was made from the "ink" secreted by cuttlefish or squid. It was never used as an oil color, but served as an ink in ancient times and in the eighteenth century became popular for ink drawings and as a watercolor pigment. The modern watercolor called sepia is made from a dye.

Mummy brown, made by grinding up the embalmed corpses of ancient-Egyptian mummies, is said to have been available until the mid 1920s.

WHITES

Lime white was made by soaking powdered slaked lime for about eight days.

White lead – also known as *flake white* – has been in use since classical times. The traditional method of making it is to expose sheets of lead to acetic-acid vapor, which transforms the metal into a white, crumbly mass. Particularly in its powdered form, white lead is highly poisonous; when bound in oil, it is much harder for it to be absorbed by the body.

BLACKS

Charcoal black was made from charred vine clippings; and *ivory black* from ivory or other animal bones. Another black was made from burnt almond shells or peach stones. To make *lamp black*:

"Take a lamp full of linseed oil, and fill the lamp with this oil, and light the lamp. Then put it, so lighted, underneath a good clean baking dish, and have the little flame of the lamp come about to the bottom of the dish, two or three fingers away, and the smoke which comes out of the flame will strike on the bottom of the dish, and condense in a mass. Wait a while; take the baking dish, and with some implement sweep this colour, that is, this soot, off onto a paper, or into some dish."

From IL LIBRO DELL'ARTE by
CENNINO CENNINI, c. 1435

SETTING OUT THE PALETTE

All sorts of containers have been used for holding paint – including mussel shells. The traditional oil painter's palette, made of wood with a hole for the thumb, was introduced early in the fifteenth century. Eventually the word "palette" came to mean not only the board used for holding the paint, but the range of colors employed as well.

Before beginning work, the artist should lay out a full range of colors on the palette in an appropriate order. William Williams, writing in the eighteenth century, advised the following:

"Place the white next to the thumb, or to the right end of the palet as it is held, patent yellow next, ranging them in the following order; next to the patent yellow, ditto oaker, Siena earth, vermilion, red oaker, purple brown, lake, burnt umber, Antwerp brown, black, Prussian blue."

From ESSAY ON THE MECHANIC OF OIL COLOURS by WILLIAM WILLIAMS, 1787

STORING PAINT

Over the ages, paints and pigments have been stored in various ways. Powdered colors were kept in glass jars, or sometimes in twists of paper. Pigments could also be ground up with their binding agents, placed in animal bladders, and tied up. When the paint was needed, the bladder would simply be pierced with a tack, the paint squeezed out, and the tack replaced. "Bladder colors" were followed by oil paints in metal or glass syringes. Finally, in 1841, the collapsible metal paint tube was invented by the American portrait painter John G. Rand. The early watercolors used by illuminators and miniaturists were "stored" on small pieces of linen – the cloth being steeped in the liquid color, then dried. When required, a fragment of cloth would be cut off and soaked overnight to release the color, which could then be mixed with a suitable medium. Watercolors became available in cake form in the 1760s, and in metal tubes in 1846.

TESTING PAINT FOR PERMANENCE

To test whether a color is resistant to fading, try the following. Place a sample of the color under a piece of glass, and spread aluminum foil over half the glass so that half the paint sample is covered; then leave the paint and glass in direct sun or strong daylight for a month. If, when you remove the foil at the end of this time, the exposed part of the sample is the same as the unexposed part, then the color is light-fast.

A WORD OF WARNING

It is a false economy to use cheap varieties of paint, as they will contain less pigment than good-quality ones and will therefore lack strength and clarity of color:

"Value your time above the cost and price of your Colours, and spare not to waste the latter to gain or save the former. 'Tis no good Husbandry to starve a Picture to save charges; besides, thin Painting is neither Beautiful nor holding."

From THE ART OF PAINTING AFTER THE ITALIAN MANNER by JOHN ELSUM, 1704

The same principles apply to gold leaf used for gilding:

"Most people make a practice of embellishing a wall with golden tin, because it is less costly. But I give you this urgent advice, to make an effort always to embellish with fine gold, and with good colours, especially in the figure of Our Lady. And if you wish to reply that a poor person cannot make the outlay, I answer that if you do your work well, and spend time on your jobs, and good colours, you will get such a reputation that a wealthy person will come to compensate you for the poor one... As the old saying goes, good work, good pay."

From IL LIBRO DELL'ARTE by CENNINO CENNINI, c.1435

AN UNUSUAL MORDANT

Adhesives known as "mordants" were used to make gold leaf adhere to the chosen surface. This particular mordant had rather unusual ingredients:

"Take clean garlic bulbs, to the volume of two or three porringers, or one; pound them in a mortar, squeeze them through a linen cloth two or three times. Take this juice, and work up a little white lead and bole with it, as fine as ever you can... And when you want to use any of this mordant, put a little of it into a little glazed dish with a small amount of urine, and stir it up thoroughly with a straw."

From IL LIBRO DELL'ARTE by CENNINO CENNINI, c.1435

BRUSHES

In ancient Egypt brushes were made from bunches of twigs, and also from palm fiber. In the Middle Ages, the writer Theophilus recommended that they be made from "the tail of a martin, badger, squirrel, or cat, or from the mane of a donkey." Brushes were divided into two kinds: "pencils" that were made of soft, flexible hairs bound into a quill holder; and "brushes" made of stiffer, larger hairs, fixed onto a wooden handle with waxed thread.

Nowadays, soft brushes made from either sable, squirrel or nylon are produced for watercolor painting and more delicate work in oils, while stiffer, hog's-hair brushes are used for oil painting. However, you can use almost anything to apply paint in order to achieve the desired effect:

"I continue to get further away from the usual painter's tools such as easel, palette, brushes, etc. I prefer sticks, trowels, knives, and dripping fluid paint or a heavy impasto with sand, broken glass, and other foreign matter added."

JACKSON POLLOCK, 1947

HOW TO MAKE "BRUSHES"

"First get bristles of a white hog, for they are better than black ones; but see that they come from a domestic hog. And make up with them a large brush into which go a pound of these bristles; and tie it to a good-sized stick with a plowshare bight or knot."

From IL LIBRO DELL'ARTE by CENNINO CENNINI, c. 1435

TESTING THE QUALITY OF BRUSHES

"In chusing Pencils… put them into your mouth, and moisten them a little, then draw them forth between the Toung and the Lip, and if they come with an entire sharp point without cleaving in twain they are good."
From THE ART OF PAINTING IN OYL by JOHN SMITH, 1676

HOW TO MAKE "PENCILS"

"Take miniver tails… and these tails should be cooked, and not raw… first pull the tip out of it, for those are the long hairs; and put the tips of several tails together … Then go back to the tail, and take it in your hand; and take the straightest and firmest hairs out of the middle of the tail; and gradually make up little bunches of them; and wet them in a goblet of clear water, and press them and squeeze them out, bunch by bunch, with your fingers. Then trim them with a little pair of scissors; and when you have made up quite a number of bunches, put enough of them together to make up the size you want your brushes: some to fit in a vulture's quill; some to fit in a goose's quill; some to fit in a quill of a hen's or dove's feather. When you have made these types… take thread or waxed silk, and tie them up well with two bights or knots… Then take your feather quill which corresponds to the amount of hairs tied up, and have the quill open, or cut off, at the end; and put these tied-up hairs into this tube or quill."
From IL LIBRO DELL'ARTE by CENNINO CENNINI, c. 1435

MINIVER Ermine or
a similar fur.

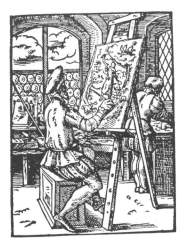

SUPPORTS

The material on which a work is painted is called the "support," and throughout the ages a variety of materials have been used – ranging from wood and copper to vellum and linen.

WOOD

Wood was one of the earliest supports used by painters and was prepared in a variety of ways. Egyptian painters covered their panels with muslin, glued on with size and coated with gesso – a process known as "marouflage." Later, the wood was coated with several layers of gesso to create a surface that was as smooth as ivory, and pure white. This led to a precise, delicate style of painting, in which the colors were laid on thinly to allow the gesso to glow through. One of the attractions of gesso is that it could be inscribed and punched into patterns – or even built up into raised patterns – which showed up to their full advantage when the gesso was gilded and burnished to a rich golden glow.

Larger wooden panels had to be glued together from smaller pieces. A waterproof glue made from cheese and quicklime was recommended. One advantage wood had over canvas was that if your picture wasn't big enough or quite the right shape, you could simply glue extra bits on – as the great Dutch painter Peter Paul Rubens (1577-1640) appears to have done.

COPPER

Copper plates were used by painters from the early seventeenth century. Copper had several advantages. Unlike plain wood, it did not crack; but, like gessoed wood, it gave colors a luminosity and had a naturally smooth surface. This extreme smoothness did present a problem, though: how was the artist to get paint to adhere? Some artists overcame the difficulty by mixing honey or sugar with either garlic juice, ox-gall, gum arabic or the gum of the fig tree, and then rubbed the unprimed copper with the mixture to prevent the paint from cracking. Other artists liked to prime the copper with white lead, overlaid with gold or silver leaf.

CARD AND VELLUM

Miniaturists, if they could not get hold of any ivory, which was rare and costly, were forced to work mostly on prepared card or vellum:

"Take an ordinary playing Card, pollish itt and make itt so smoth as possible you can, ye whitt side of itt, make it evry wheare even and clean frome spots, then chuse the best abortive Parchment and, cutting a peece Equall to yor Card, with fine and Cleane starch paste it on the Card, which done Lett itt dry, then making yor Grind stone as Cleane as may bee, lay the Card on the stone, the parchment side downeward, and then Pollish itt well on the backe side, itt will make much the smother, you must paste yor parchment so that the out side of the skinn may be outward, itt being the smothest and best side to worke on."

From A MORE COMPENDIOUS DISCOURSE CONCERNING THE ART OF LIMNING by EDWARD NORGATE, 1648-50

THE ADVANTAGES OF CANVAS

The advantages of this lightweight material had long been known. In ancient Rome, Pliny spoke of a "thing previously unheard of" – an enormous portrait of the Emperor Nero, 120ft long, painted on canvas, which was displayed in public places. Presumably it could be rolled up and stored away when not in use.

Originally canvas was not considered a suitable support for the serious painter, and for a long time it was only thought worthy of "stainers" who produced cloth hangings. It was the sixteenth-century painters of the Venetian School, such as Titian and Giorgione, who made it acceptable for more exalted forms of art. The rougher surface of canvas led to a freer, more "unfinished" style of painting – and the shocking habit of leaving areas of canvas semi-bare of paint.

The luxury of buying canvas in whatever width you wanted only became possible with the improvements in textile manufacture that were introduced in the mid eighteenth century. Until then, cloth could not be woven more than 3ft wide, so wider canvases had to be sewn together from strips.

Canvas may be made of either linen or cotton. Linen is generally to be preferred, having a pleasing, slightly uneven surface and greater elasticity. The thicker grades of cotton canvas, known as cotton duck, are as durable as linen canvas. To tell whether a canvas is made of linen or cotton, unwind a thread. If it is made of cotton, it will become fluffy; if it is made of linen, it will separate into strands.

"In order to be able to convey pictures from one place to another, men have invented the convenient method of painting on canvas, which is of little weight, and when rolled up is easy to transport."
From LIVES OF THE ARTISTS by GIORGIO VASARI, 1568

HOW TO STRETCH A CANVAS

Prepared canvases may be bought in standard sizes, but stretching a canvas at home gives the artist greater freedom of choice in terms of size and quality of material. Canvas is stretched on a frame of wooden stretcher bars. With early paintings, the picture frame itself sometimes served as a stretcher. Canvases that are more than 40-50in wide or high need reinforcing by crossbars fitted between the stretchers to prevent them from twisting.

Canvas needs to be stretched firmly and evenly. Special canvas pliers make this job easier than if you use your bare hands.

After joining the stretcher bars, check the corners with a carpenter's square to make sure they are true. The canvas should be cut 1in wider all round than the finished size. Using upholstery tacks or a staple gun, fix the canvas to the middle of one bar. Pull the canvas tightly towards each end of the bar; then tack it down, placing the tacks at 2in intervals. Repeat the process with the opposite bar, pulling the canvas across it as firmly as you can.

Pull the fabric across the two remaining bars, tacking it in place as you do so. Finally, fold over the corners, cutting away any excess canvas, and tack in place. Tidy up any loose canvas along the sides by folding it over and tacking it down.

"My painting does not come from the easel. I hardly ever stretch my canvas before painting. I prefer to tack the unstretched canvas to the hard wall or the floor. I need the resistance of a hard surface… this way I can walk around it, work from the four sides and literally be in the painting. This is akin to the method of the Indian sand painters of the West."
JACKSON POLLOCK, 1947

HOW TO SEAL A CANVAS

After stretching, canvas needs to be sealed by sizing. The correct size for this purpose is traditionally made from hide glue, in the proportions of 1oz of glue to 1 pint of water. Dissolve the glue by heating it in the water, and allow it to cool to a gel consistency. Spread the size over the canvas with a spatula, pressing it into the tiny gaps in the fabric to seal them. If it were applied in liquid form, the size would seep through to the back, leaving the canvas only partly sealed. The canvas should be left to dry slowly at room temperature (if extra heat is applied, the size film will separate). When the canvas is dry, the roughened surface may be lightly sanded to smooth it, then given a second, faster-drying coat of size.

CORRECTING A WARPED CANVAS

The pull of the canvas may cause some of the larger stretchers to twist. This can be corrected after it has been sized. While it is still wet, lay it on the floor, with a weight on each corner, and the canvas will dry flat.

TIGHTENING A CANVAS

Stretchers are normally supplied with slots at each end into which wooden wedges can be inserted. If a canvas has become slack, tap wedges into these slots to open the stretchers and tighten the canvas. Alternatively, you can make the canvas tauter by damping the back with hot water and leaving it to dry.

HOW TO PRIME A CANVAS

After it has been sized, the canvas needs to be primed to provide a surface suitable for painting. Early canvases were primed with gesso; but this was not ideal, as the surface tended to peel and was likely to crack if the canvas was rolled up. Gesso was therefore later replaced by oil-based primers.

Canvas is commonly coated with a white primer. This may be made from white-lead paste, thinned with a little copal painting medium and applied with a spatula, in the same way as the size. To prevent the canvas being pressed against the stretchers and creased, insert cardboard between the stretchers and the canvas. One or more coats of primer may be applied. To speed drying, add a little raw or burnt umber oil paint to the white-lead paste.

COPAL PAINTING MEDIUM
A mixture of copal resin, stand
oil (see p. 25) and turpentine.

"A paste … is made of flour and of walnut oil, with two or three measures of white lead put into it, and after the canvas has been covered from one side to the other with three or four coats of smooth size, this paste is spread on by means of a knife, and all the holes come to be filled up by the hands of the artist. That done, he gives it one or two more coats of soft size, and then the composition of priming."
From LIVES OF THE ARTISTS by GIORGIO VASARI, 1568

CHOOSING WATERCOLOR PAPER

There are three basic varieties of watercolor paper:

- *Hot-pressed paper*, which has a smooth surface, is best for line drawing combined with washes of color.
- *Cold-pressed paper* with a semi-rough surface is a good all-round paper.
- *Rough paper* produces a speckled effect because of its highly textured surface.

Japanese rice paper may also be used for watercolor.

STRETCHING WATERCOLOR PAPER

Watercolor paper comes in a variety of weights, from around 70 lbs to 300 lbs or more. Lighter papers tend to buckle when wet, so need to be stretched before beginning work. To do this, place the paper in a tray of water, then remove it and shake off excess water. Lay the paper right side up on a drawing board; tape down the edges with strips of brown gummed paper and place a drawing pin in each corner. As the paper dries, it will tighten and become smooth.

WATERCOLOR TRICKS

To apply an even wash of color, first paint the required area of paper with water; then while the paper is still wet, "float" the color on – it will spread by itself to the edges of the wet area. To remove excess color, lift off the paint by dabbing with a dry brush.

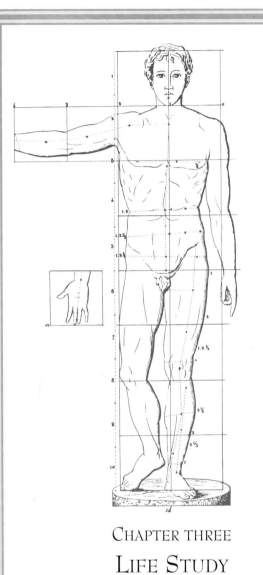

Chapter three
Life Study

"And who is so barbarous as not to understand that the foot of a man is nobler than his shoe, and his skin nobler than that of the sheep with which he is clothed, and not to be able to estimate the worth and degree of each thing accordingly?"

Michelangelo Buonarroti (1475-1564)

THE SEARCH FOR BEAUTY

*"Because of the horror he felt for the insipid ideal,
Caravaggio corrected none of the defects of the models he
stopped in the streets to ask to pose for him. I have seen in
Berlin some paintings of his which were refused by the
persons who had commissioned them for being too ugly."*
From ROME, FLORENCE, NAPLES by STENDHAL, 1817

In order to portray the ideal figure, many artists used a
"mix-and-match" approach, using different models for
different parts of the body. When John Rysbrach
(1694-1770) – a Dutch sculptor who settled in England
– began work on a statue of Hercules, he chose as his
models "seven or eight of the strongest and best made
men in London, chiefly the bruisers and boxers of the
then flourishing amphitheatre for boxing." The arms
belonged to one man, the chest to another, and the
legs were those of "Ellis the painter, a great frequenter
of the gymnasium."

Joseph Nollekens (1737-1823), one of the leading
sculptors of his day, went even further, using casts of
feet because English models had "very bad toes in
consequence of their abominable habit of wearing
small pointed shoes."

Nevertheless, there were pitfalls in this approach.
John Elsum, writing in the early eighteenth century,
stated that he knew of "no greater folly than of those
who sometimes in their Works of Nudity put things
that are ridiculous [such] as a delicate Head and tender
Limbs [with] a Body full of Muscles."

*"A model! A model! What the hell would I do with a
model? When I need to verify something, I go out and
find my wife in the kitchen."*
ARISTIDE MAILLOL (1861-1944) – as reported by ANDRÉ GIDE

THE LENGTH OF THE POSE

Poses vary in length, from short ones lasting as little as five minutes – designed to get the artist working quickly and loosely – to those intended for more-detailed study, which may continue for a day or more. In the case of the extended pose, remember that the model's body will relax and settle as the pose progresses, so you should allow for these changes to take place before committing any definitive marks to paper.

Posing for an artist is a tiring business, and the length of the sessions should give the model intervals in which to rest. But artists need to take regular breaks, too, and at the Royal Academy in London a special "hour glass," timed to run for seven minutes, was used to remind artists how long they had been working.

A KNOWLEDGE OF ANATOMY

"Nature is always the same, and therefore the muscles of the figures are not to be varied at whim."
JACOPO ROBUSTI TINTORETTO (1518-94)

To gain a full understanding of how the skeleton and muscles worked, artists once had to resort to dissecting the cadavers of executed criminals. For obvious reasons, dissection was best carried out during the winter.

In *Johann Deyman's Anatomy Lesson*, painted in 1656, Rembrandt used the corpse of Joris Fonteijn, known as "Black Jan," who was executed in January of that year. One painter, Aert Mytens (1541-1602), even went so far as to creep out at night to cut down a body from a gallows, so that he could continue his studies.

Perhaps the most gruesome product of anatomical research was the "flay" – a cast taken from a cadaver whose skin had been removed in order to show the underlying muscular formation. One such cast was made by the anatomist Joseph Constantine Carpue at the request of – among others – Benjamin West, an American painter and one-time President of the Royal Academy of Art in London. The model was Ensign James Legg, executed in 1801 for murder.

PROPORTIONS

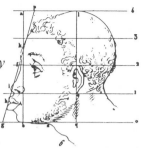

*"There is no excellent Beauty
that hath not some Strange-
nesse in the Proportion."*
FRANCIS BACON (1561-1626)

A convenient way of checking the proportions of a
figure is to take the length of the head as a measure.
The number of "heads" in a figure varies, depending
on age. In infancy, measuring from the crown of the
skull to the soles of the feet, there are 4 heads in a
figure; this rises to 4½ heads at the age of two. At the
age of eight, there are about 6 heads; and at fourteen,
nearly 7 heads. The figure of an adult person is equal
to 7½ heads, shrinking to 7 in old age.

*"I find a great difference between men and small boys
in the length from one joint to another; for whereas
the distance from the joint of the shoulder to the elbow
to the tip of the thumb, and from the humerus of one of
the shoulders to the other, in a man is twice the head,
in a child it is only once, because nature fashions the
stature of the seat of the intellect for us before that of its
active members."*
LEONARDO DA VINCI (1452-1519)

BODY TYPES

While following the rules of proportion, the artist may
find that all his or her figures have begun to conform
to the same "ideal," and therefore lack variety and
interest. When depicting the human form, the artist
should become sensitive to individual differences. It
may be helpful to bear in mind the work of Dr W. H.
Sheldon, who divided the figure into three basic types:
the rounded endomorph; the muscular mesomorph;
and the slender ectomorph. Most people are, in fact, a
combination of all three.

THE PERFECT MAN

In his artist's handbook *Il Libro dell'Arte* – completed "in the debtors' prison in Florence" – the Italian painter Cennino Cennini dismissed women and animals as "too irrational" to have predictable proportions, but gave the following guidelines for the proportions of the perfectly formed man:

"Take note that... I will give you the exact proportions of a man. Those of a woman I will disregard, for she does not have any set proportion... From the shoulder to the elbow, one face. From the elbow to the joint of the hand, one face and one of the three measures. The whole hand, lengthwise, one face. From the pit of the throat to that of the chest, or stomach, one face. From the stomach to the navel, one face. From the navel to the thigh joint, one face. From the thigh to the knee, two faces. From the knee to the heel of the leg, two faces. From the heel to the sole of the foot, one of the three measures. The foot, one face long. A man is as long as his arms crosswise. The arms, including the hands, reach to the middle of the thigh. The whole man is eight faces and two of the three measures in length. The handsome man must be swarthy, and the woman fair... I will not tell you about the irrational animals, because you will never discover any system of proportion in them."

From IL LIBRO DELL'ARTE by CENNINO CENNINI, c. 1435

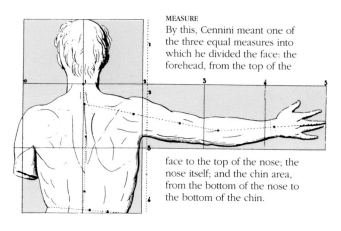

MEASURE
By this, Cennini meant one of the three equal measures into which he divided the face: the forehead, from the top of the face to the top of the nose; the nose itself; and the chin area, from the bottom of the nose to the bottom of the chin.

THE THUMB MEASURE

An effective trick when drawing from life is to use the pencil and thumb as a kind of slide rule. The pencil is held up before the eye, in line with the figure, and the thumb slid up and down it to assess and compare relative proportions. For this system to work, however, three rules must be followed:

- The arm holding the pencil must be fully extended to maintain a consistent distance from the eye.
- The pencil must be lined up with the same eye for each measurement.
- The eye and head must always be returned to the same position for all measurements.

WOODEN MODELS

Another useful aid for life study was the "lay figure." These wooden models, similar to the small mannikins still available in art shops today, were used from the fifteenth century onwards. Often life-size, they were beautifully modeled in fine detail and were able to bend at every joint, just like a live model – sometimes even having jointed fingers and toes. Later, such figures were sometimes made of papier mâché.

Small clay models were popular, too. The great Italian master Piero della Francesca (c. 1416-92) is said to have draped these little figures with wet cloths in order to study drapery.

THE MOVING FIGURE

"Let the movements of young lads be limber and joyous, with a certain display of boldness and vigour. Let mature men have steadier movements, with handsome and athletic postures. Let old men have fatigued movements and attitudes and not only support themselves on both feet but hold on to something with their hands as well.

LEON BAPTISTA ALBERTI (1404-72)

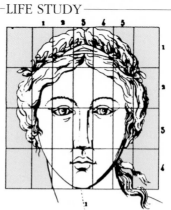

THE HUMAN FACE

"The face is divided into three parts, namely: the forehead, one; the nose, another; and from the nose to the chin, another. From the side of the nose through the whole length of the eye, one of these measures. From the end of the eye up to the ear, one of these measures. From one ear to the other, a face lengthwise... From the chin under the jaw to the base of the throat, one of the three measures. The throat, one measure long. From the pit of the throat to the top of the shoulder, one face."

From IL LIBRO DELL'ARTE by CENNINO CENNINI, c. 1435

A PAINTER'S REVENGE

When commissioned to paint a portrait of Lady Cunard, Marie Laurencin included the form of a strange fantasy horse. Lady Cunard hated the painting and promptly returned it – whereupon Laurencin, feeling that her artistic integrity was at stake, reworked it showing the subject of the portrait sitting astride a camel. When Lady Cunard heard about it, she was horrified. What ridicule she would face if the painting was included in an exhibition or reproduced in a society journal! But she soon came up with a plan to placate the vengeful artist – she commissioned Laurencin to paint murals for a whole ballroom, in the hope that she might be persuaded to alter the offending beast.

"What is a portrait? Is it not an interpretation of the human sensibility of the person represented?"

HENRI MATISSE (1869-1954)

WARTS AND ALL

"I desire you would use all your skill to paint my picture truly like me; but remark all these roughnesses, pimples, warts, and everything as you seeme, otherwise I will never pay a farthing for it."
From ANECDOTES OF PAINTING IN ENGLAND by HORACE WALPOLE, 1762

Oliver Cromwell, the leader of the victorious Parliament-arians during the English Civil War, did not hold with flattery and is said to have made the above remark to the young painter Peter Lely when he was about to begin work on his portrait.

WITHOUT FUSS OR FEATHERS

The American poet Walt Whitman was capable of appreciating honesty, too. Speaking of the painter Thomas Eakins (1844-1916), he said:

"Of all the portraits of me made by artists, I like Eakins' best. It gets me there – fulfills its purpose, sets me down in correct style, without feathers, without fuss of any sort. I like the picture always – it never fades or weakens. It is not perfect, but it comes nearest being me."

A GOOD FLESH COLOR

Light cinabrese, made from the "handsomest and lightest sinoper" (see p.28) was said to be perfect for painting flesh, especially for use in fresco. To make up a suitable flesh color, it was mixed and worked up with lime white:

"And when these two colours are well worked up together, that is, the two parts cinabrese and the third lime white, make little cakes of it, like halves of nuts, and let them dry. Whenever you need some, take what you think fit; for this colour does you great credit in painting countenances, hands, and nudes on the wall."
From IL LIBRO DELL'ARTE by CENNINO CENNINI, c.1435

HOW TO PAINT AN OLD MAN'S BEARD

"Now, assuming that your old man's hair and beard are hoary, when you have got it shaped up with verdaccio and white with your sharp miniver [ermine] brush, take some lime white mixed with a small amount of black in a little dish, liquid; and with a blunt and soft bristle brush, well squeezed out, lay in the beards and hair; and then take some of this mixture a little bit darker, and shape up the darks. Then take a small, sharp, miniver brush, and stripe delicately over the reliefs of these hairs and beards."

From IL LIBRO DELL'ARTE by CENNINO CENNINI, c.1435

THE BEAUTY OF AGE

"No Spring, nor Summer Beauty hath such grace, As I have seen in one Autumnall face."

From THE AUTUMNALL by JOHN DONNE (1572-1631)

The American painter Thomas Eakins would have agreed with the above sentiment. Eakins never shrank from painting his sitters as he saw them, wrinkles and all. "How beautiful an old woman's skin is!" he once exclaimed. "All those wrinkles!"

But there were those who did not agree – especially some of the older women whose portraits he painted. Whenever visitors were perusing one such portrait, the daughters of the unfortunate sitter would hasten to explain that their mother had been unwell when the portrait was painted.

MICHELANGELO'S DAVID

Michelangelo's *David* is one of his most famous sculptures. Its beginnings were most un-promising, however. The huge block of marble from which he was to fashion *David* had already been worked on by another sculptor, Simone da Fiesole. In an attempt to carve the legs of a giant figure, Fiesole had hacked away at the marble, mutilating it so severely that his patrons had made him

leave the project unfinished. For many years the damaged block lay abandoned, but Michelango was determined to get hold of it – and finally managed to do so in 1501, when he returned to Florence from Rome. Although somewhat hampered by da Fiesole's carving, he immediately set to work, surrounded by a screen so that no one could see what he was doing. In 1504 the finished sculpture was moved to the Piazza della Signoria and unveiled – to reveal the masterpiece that Michelangelo had seen locked within an apparently useless block of stone.

NOTE The original sculpture is now in the Galleria dell'Arte, in Florence, and a copy made by Michelangelo stands in the Piazza della Signoria.

"In envisaging the imitation of the surface of the human body, sculpture must not limit itself to [creating] cold resemblance such as the body of man might have had before it received the breath of life … Nature alive, breathing, and passionate – this is what the sculptor must express in stone or marble."
ÉTIENNE-MAURICE FALCONET (1716-91)

Chapter four:
Back to Nature

*"When you go out to paint, try to forget
what objects you have in front of you, a tree,
a field... Merely think, here is a little square of
blue, here an oblong of pink, here a streak of
yellow, and paint it just as it looks to you, the exact
colour and shape, until it gives your own naive
impression of the scene."*

Claude Monet (1840-1926)

THE LANDSCAPE TRADITION

The desire to paint a picture of the countryside, devoid of figures, may seem perfectly natural to us now – but prior to the 1600s the notion might have seemed slightly eccentric. Although landscape painting had been an acceptable form of art in China for many centuries, in the West landscape was generally only considered suitable as a backdrop for figures. It wasn't until the seventeenth century that landscape painting as such really flowered in Europe, in the hands of such Dutch masters as Hobbema and van Ruysdael. These innovators were followed by Claude Lorrain in France; then Gainsborough, Turner, and Constable in England; and eventually by the Impressionists and their contemporaries in the nineteenth century. In the twentieth century, landscape is still one of the most popular subjects for artists working in all styles and media.

THE WONDERS OF WINE

To break through artistic inhibitions and achieve a blithely mystical response to nature, Chinese landscape painters sometimes resorted to wine. Before beginning a painting, Wang Hsia (also known as Wang Mo, or "Ink Wang") used to get drunk – and then, laughing and singing, would fling ink onto the scroll. Rubbing it about with his hands, or splattering or scrubbing it on with his brush, he would follow whatever forms the ink suggested, turning them into mountains, rocks, clouds, or water. And all this was achieved without so much as a single unwanted blot of ink.

Wu Chen, one of the Six Great Masters of the Yuan period (1279-1368), also found wine an effective aid, as one commentator explained:

"When he got drunk, he swung the brush and painted the air of the mountains, the haze, the mist and the clouds flawlessly."

CHINESE LANDSCAPE

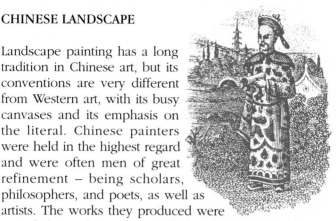

Landscape painting has a long tradition in Chinese art, but its conventions are very different from Western art, with its busy canvases and its emphasis on the literal. Chinese painters were held in the highest regard and were often men of great refinement – being scholars, philosophers, and poets, as well as artists. The works they produced were regarded as subjects for meditation. In a misty Chinese landscape, features may be indicated with no more than a few brushstrokes and a wash – and the "emptiness" of the unfilled spaces is as important as the objects between them.

Such refinement of style and technique took years of practice and entailed careful preparation. Before putting brush to paper, the Chinese artist would sit on the floor, or on a low seat, with brushes of various sizes, a water pot, and pigment or ink sticks of compressed soot to hand. Having laid out his materials, he would dip the sticks into the water then grind them on a special stone, varying the quantities of ink and water to suit the effect he wished to achieve. Holding his brush at a right angle to the wrist and moving his arm from the shoulder, he would then sweep the surface with the tip of the brush to create thick or thin lines, or to spread a wash.

This was an unforgiving technique – as mistakes could not be erased or painted over, and preliminary sketches were rarely done. Nevertheless, one Chinese painter, Chang Tsao, famed for his paintings of pine trees, was so skillful that he was once seen wielding two brushes simultaneously, painting a live branch with one and a dead branch with the other.

FRENCH LANDSCAPE

"I do not wonder at you being jealous of Claude. If anything could come between our love it is him."
JOHN CONSTABLE (1776-1837) – in a letter to his wife

The celebrated French landscape painter Claude Lorrain (1600-82) studied the countryside around Rome in order to produce paintings of serene rural beauty that were to serve as an inspiration for artists and landscape designers for decades to come. Indeed so strong was his influence that it became common when judging a vista to classify it as "picturesque" (or not) depending on how closely the landscape conformed to the Claudian ideal.

Claude's paintings were built up using a series of graduated tones. Benjamin West (1738-1820), the American painter who succeeded Joshua Reynolds as President of the Royal Academy, described exactly how this was achieved:

"Claude began his pictures by laying in simple gradations of flat colours from the Horizon to the top of the sky – and from the Horizon to the foreground, without putting clouds into the sky or specific forms into the landscape until He had fully settled those gradations. When he had satisfied himself in this respect, He painted in his forms, by that means securing a due gradation – from the Horizontal line to the top of his sky, and from the Horizontal line to the foreground."
BENJAMIN WEST – quoted in THE DIARIES OF JOSEPH FARINGTON (1747-1821)

THE CLAUDE GLASS

This device, said to have been used by Claude Lorrain, was popular with landscape painters from the seventeenth century onwards, as it helped them to assess tonal contrasts in a scene. The glass consisted of a black convex mirror in which the reflection of a landscape could be viewed, the blackness modifying the colors to a series of tonal gradations – rather like a modern black-and-white photograph.

A RECIPE FOR LANDSCAPE

The fashionable landscape painters who imitated Claude developed an easy "recipe" for producing a pleasing painting:

- An impressive tree or other large object should be placed in the foreground of the picture to "frame" the scene and serve as a contrast to the view that opened up beyond.
- The foreground should be painted in warm tones such as browns and golds – the idea being that warm colors come forward.
- The background should fade away into pale blues, since cool colors recede.

There were also recipes for painting clouds, and for representing the bark of gnarled trees.

ENGLISH LANDSCAPE

"The sound of water escaping from Mill dams… willows, Old rotten Banks, slimy posts, and brickwork. I love such things… They made me a painter… I had often thought of pictures of them before I had ever touched a pencil."
JOHN CONSTABLE (1776-1837)

Constable was somewhat ruefully conscious that in some people's minds his landscapes were irrevocably associated with typical English weather:

"Speaking of me, he [Fuseli] says, 'I like de landscapes of Constable; he is always picturesque, of a fine colour, and de lights always in de right places; but he makes me call for my greatcoat and umbrella.'"
JOHN CONSTABLE, 1823

COMPETING WITH CLAUDE

"So airy is his work – it is as if he were painting with tinted steam."
JOHN CONSTABLE (1776-1837) on the paintings of JOSEPH TURNER

While Constable was very much a realist, wanting to paint what he saw, Joseph Turner (1775-1851) looked back to the visionary landscapes of Claude Lorrain – his ambition being to attain, or even surpass, the standard of the French artist's work. Such was Turner's sense of competitiveness that in his will he bequeathed his paintings and sketches to the nation on condition that one of his own pictures should always be displayed side by side with one of Claude's.

THE CULINARY ART OF JOSEPH TURNER

Not surprisingly, Turner's paintings (which were exhibited at the Royal Academy for the first time in 1796, when he was only twenty-one) aroused fierce controversy – but, curiously, his detractors seem to have been almost compulsively drawn to culinary language in expressing their criticism:

"Here is a picture that represents nothing in nature beyond eggs and spinach. The lake is a composition in which salad oil abounds, and the art of cookery is more predominant than the art of painting."
From a review of TURNER'S SCHLOSS ROSENBAU in THE TIMES, 1841

"A tortoiseshell cat having a fit in a platter of tomatoes."
MARK TWAIN (1835-1910) on TURNER'S THE SLAVE SHIP

John Ruskin's reaction to *The Slave Ship* could not have been more different:

"But, I think, the noblest sea that Turner has ever painted, and, if so, the noblest certainly ever painted by man, is that of 'The Slave Ship'... I believe, if I were to reduced to rest Turner's immortality upon any single work, I should choose this."

AMERICAN LANDSCAPE

Thomas Cole, who arrived in the United States in 1818 from England and later became a leading American landscape painter, was delighted to find a countryside untouched by the artist's brush:

"The painter of American scenery has, indeed, privileges superior to any other. All nature here is new to art. No Tivolis, Ternis, Mount Blancs…hackneyed and worn by the daily pencils of hundreds."

The writer Henry James was less impressed with the fresh beauty of the American countryside. Speaking of the painter Winslow Homer (1836-1910), he said:

"We frankly confess that we detest his subjects – his barren plank fences, his glaring, bald, blue skies, his big, dreary vacant lots of meadows, his freckled, straight-haired Yankee urchins, his flat-breasted maidens, suggestive of a dish of rural doughnuts and pie…He has chosen the least pictorial features of the least pictorial range of scenery and civilization."
From ON SOME PICTURES LATELY EXHIBITED by HENRY JAMES, 1875

STUDYING NATURE

A friend once found Douanier Rousseau (1844-1910) painting with a wreath of leaves tied around the thumb that stuck through the hole in his palette. When asked why he was wearing the bouquet, although there were no leaves in the painting on which he was working, Rousseau's terse reply was "One must study nature."

"If we study Japanese art, we see a man who is undoubtedly wise, philosophic and intelligent, who spends his time doing what? In studying the distance between the earth and the moon? No. In studying Bismarck's policy? No. He studies a single blade of grass."
VINCENT VAN GOGH (1853-90)

THE COLORS OF LANDSCAPE

"Nature here [at Arles is]... so extraordinarily beautiful. Everywhere and all over the vault of heaven is a marvellous blue, and the sun sheds a radiance of pale sulphur, and it is soft and as lovely as the combination of heavenly blues and yellows in a Van der Meer of Delft."
VINCENT VAN GOGH (1853-90)

Constable broke with the earlier landscape tradition by using fresher, brighter colors in his paintings. When his patron, Sir George Beaumont, remonstrated with him for not giving the grass in his foreground the customary mellow brown of an old violin, Constable placed a violin on the grass to demonstrate the immense difference between the true color of grass and the color that was required by fashion.

On another occasion, when Constable was sitting on the judging panel of the Royal Academy, one of his own paintings was brought before the panel by mistake. Not knowing who had done the painting, one of the other judges rejected it out of hand, indignantly exclaiming "Take that nasty green thing away!"

"When grass is lighted strongly by the sun in certain directions, it is turned from green into a peculiar and somewhat dusty-looking yellow... Very few people have any idea that sunlighted grass is yellow."
JOHN RUSKIN, 1856

FLOWER PAINTING

Although an inspired painter of landscapes and still lifes, Georgia O'Keeffe (1887-1986) is perhaps best known for her startling paintings of flowers. It has often been claimed that the huge blooms that dominate her canvases have sexual connotations – an interpretation that greatly irritated the artist, who maintained that this was all in the mind of the beholder. "I hate flowers," she once snapped, exasperated by the whole debate. "I paint them because they're cheaper than models and they don't move!"

HOW TO PAINT CERTAIN FEATURES

Various tricks and techniques are available to the artist wishing to represent the features of the natural world:

MOUNTAINS

"If you want to acquire a good style for mountains, and to have them look natural, get some large stones, rugged, and not cleaned up; and copy them from nature, applying the lights and the dark as your system requires."

TREES AND FOLIAGE

"First lay in the trunk of the tree with pure black… and then make a range of leaves with dark green… and see to it that you make them quite close. Then make up a green with giallorino [yellow], so that it is a little lighter, and do a smaller number of leaves, starting to go back to shape up some of the ridges. Then touch in the high lights on the ridges with straight giallorino, and you will see the reliefs of the trees and the foliage. But before this, when you have got the trees laid in, do the base and some the branches of the trees with black; and scatter the leaves upon them, and then the fruits; and scatter occasional flowers and little birds over the foliage."

WATER

"Whenever you want to do a stream, a river, or any body of water… take that same verdaccio [a greeny-brown] which you used for shading the faces on the mortar; do the fish, shading with this verdaccio the shadows always on their backs; bearing in mind that fish… ought to have the dark part on top and the light underneath. Then… put on lights underneath… And make a few shadows over the fish, and all over the background, with the same verdaccio… Then, in secco, lay verdigris [green] in oil uniformly over the whole ground… but not so much that the fish and waves of water do not still show through; and, if they need it, put a few lights on the waves."

From IL LIBRO DELL'ARTE by CENNINO CENNINI, c. 1435

IN SECCO· On a dry surface
(rather than on wet plaster,
as in fresco).

HOW TO PAINT A NIGHT SCENE

*"If you wish to represent a night scene, have a great
fire in it, for then the object which is closest to this fire
will be most tinged with its colours, because that which
is nearest to an object most shares in its nature. And
in making the fire tend towards a red colour, make
everything illuminated by it reddish in colour too.
The figures which are drawn towards the fire appear
dark against the brightness of the fire because the part
of the object which you see is coloured with the dark-
ness of the night and not by the brightness of the fire.
Those who stand at the sides will be half dark and half
reddish, while those who can be seen beyond the edges
of the flames will all be lit by the reddish light against
a black background."*

LEONARDO DA VINCI (1452-1519)

THE WONDERS OF NATURE

*"There is something in painting which cannot be explain-
ed, and that something is essential. You come to nature
with all your theories, and she knocks them all flat."*

PIERRE AUGUSTE RENOIR (1841-1919)

While some artists are preoccupied with technique and
theory, others have a more direct response to nature. The
American painter Andrew Wyeth tells of an evening
spent in a New York penthouse with a group of artists,
including the abstract painters Jackson Pollock and Stuart
Davis, and Edward Hopper – a painter of deceptively
simple figurative scenes.

Pollock and Davis were heatedly discussing technique,
oblivious to all else. Outside, the sun was beginning to
set, igniting the surrounding buildings in an incredible
fiery glow. Leaning across, Hopper tapped Davis on the
shoulder and pointed out of the window.

"Can you ignore that?" he asked.

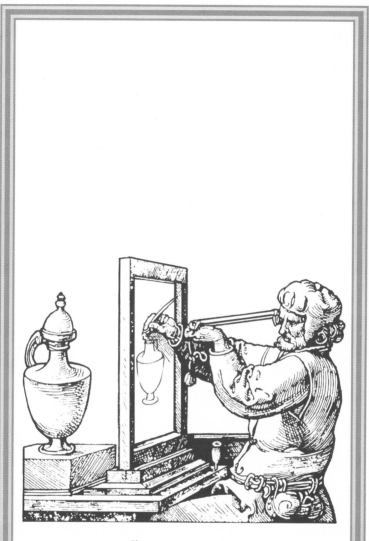

Chapter five:
Discovery and Illusion

*"A picture is something which requires
as much knavery, trickery, and deceit
as the perpetration of a crime."*

Edgar Degas (1834-1917)

HOW ART BEGAN

"I believe that the arts which aim at imitating the creations of nature originated in the following way: in a tree trunk, a lump of earth, or in some other thing were accidentally discovered one day certain contours that needed only a very slight change to look strikingly like some natural
object. Noticing this, people tried to see if it were not possible by addition or subtraction to complete what still was lacking for a perfect likeness. Thus by adjusting and removing outlines and planes in the way demanded by the object itself, men achieved what they wanted, and not without pleasure. From that day, man's capacity to create images grew apace until he was able to create any likeness, even when there was no vague outline in the material to aid him."
From ON SCULPTURE by LEON BAPTISTA ALBERTI, c. 1464

"I do not think it is too much to say that no man, however original he may be, can sit down today and draw the ornament of a cloth, or the form of an ordinary vessel... that will be other than a development or a degradation of forms used hundreds of years ago."
WILLIAM MORRIS (1834-96)

"From one point of view, the whole history of art may be summed up as the history of the gradual discovery of appearances. Primitive art starts, like that of children, with symbols of concepts. In a child's drawing of a face a circle symbolizes the mask, two dots the eyes, and two lines the nose and mouth. Gradually the symbolism approximates more and more to actual appearance, but the conceptual habits... make it very difficult, even for artists, to discover what things look like to an unbiased eye. Indeed, it has taken from Neolithic times till the nineteenth century to perfect this discovery."
From REFLECTIONS ON BRITISH PAINTING by ROGER FRY, 1934

"There is a train track in the history of art that goes way back to Mesopotamia. It skips the whole Orient, the Mayas, and American Indians. Duchamp is on it; Cézanne is on it; Picasso and the Cubists are on it; Giacometti, Mondrian, and so many, many more – whole civilizations. Like I say, it goes way in and back to Mesopotamia for maybe 5,000 years, so there is no sense in calling out names."

WILLEM DE KOONING, 1950

FIRSTS IN ART

In ancient Greece the development of art was seen as a history of technical innovations. According to Pliny, Pythagoras (fifth century B.C.) was the first sculptor to show nerves and veins in his figures. Nicias (late fourth century B.C.) was said to be the first painter to be concerned with light and shade, while Polygnotus of Thasos, who worked in Athens around the middle of the fifth century B.C., had the distinction of being the first artist to paint people with their mouths open and the first to depict hair realistically.

"His [Polygnotus'] Invention it was to paint Images with the mouth open, to make them shew their teeth, and represented much variety of countenance, far different from the stiff and heavy look of the Visage before-time."

From THE WONDERS OF THE LITTLE WORLD by NATH WANLEY, 1678

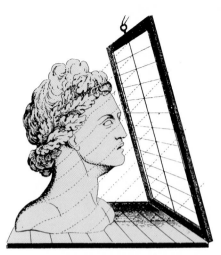

"L'exactitude n'est pas la vérité."
("Exactitude is not truth.")
HENRI MATISSE (1869-1964)

TRUE TO LIFE

For many centuries, realism was seen as the pinnacle of artistic achievement. So much so, that the Greek painters Parrhasius and Zeuxis (late fifth century B.C.) competed with one another to produce the most lifelike work:

"Parrhasius… was bold openly to challenge Zeuxis for the victory in this Art. Zeuxis brought upon the Stage a Tablet wherein clusters of Grapes were so lively represented that the Birds of the Air came flocking to them. Parrhasius to shew his Workmanship brought a Tablet wherein he had only depainted a Curtain, but so lively that Zeuxis in a glorious bravery because the Birds had approved of his Handy-work, said to him in scorn, Come Sir, away with your Curtain that we may see your goodly Picture; but perceiving his error he was mightily abashed, yielded him the Victory, and said, Zeuxis hath beguiled poor Birds, but Parrhasius hath deceived Zeuxis, a professed Artist."

From THE WONDERS OF THE LITTLE WORLD by NATH WANLEY, 1678

TOO REAL FOR COMFORT

Douanier Rousseau had a greatly heightened sense of reality. Sometimes, when working on some strange and fantastic subject, the realism of what he had painted scared him so much that he began to shake and had to open the window to get some fresh air.

The magical beliefs of certain peoples sometimes lead to confusion about what is real and what is art or artifice. When one European artist made drawings of the cattle belonging to an African tribe, the people became concerned. "If you take them away with you, what are we to live on?" they asked.

GOOD COMPOSITION

"He who studies good painting and sculpture… must necessarily have acquired a good method in art. Hence springs the invention which groups figures in fours, sixes, tens, twenties, in such a manner as to represent battles and other great subjects of art. This invention demands an innate propriety springing out of harmony and obedience; thus if a figure move to greet another, the figure saluted having to respond should not turn away… He [the artist] must always take care… that everything is in relation to the work as a whole; so that when the picture is looked at, one can recognize in it a harmonious unity, wherein the passions strike terror, and the pleasing effects shed sweetness, representing directly the intention of the painter, and not the things he had not thought of."

From LIVES OF THE ARTISTS by GIORGIO VASARI, 1568

THE JAPANESE CONNECTION

In the mid nineteenth century, when Japan began trading with America and Europe, a new influence crept into the world of art. This was the Japanese color print, perfected by artists such as Hokusai (1760-1849) and Utamaro (1753-1806). These prints were not highly regarded in the Far East, and were used as padding and wrapping for exported goods. When Manet, Degas, and other French painters, came upon them, they were struck by their bold and unconventional design. Objects would be shown from unexpected angles (such as Mount Fuji glimpsed through the curve of a wave or seen behind scaffolding); and figures might have the head, feet or hands cropped off by the edge of the print. Such practices were totally at odds with the academic tradition of the West and inspired the French painters to experiment with new styles.

An American painter also much under the spell of the Japanese was James McNeill Whistler (1834-1903). Rejecting conventional ideas about the importance of subject matter, Whistler said that what really mattered in a painting was the relationship of color and form.

In 1877 he exhibited a series of *Nocturnes* (night scenes) painted in the Japanese style, for an asking price of 200 guineas apiece. Enraged by what he regarded as sheer pretentiousness, the formidable art critic John Ruskin furiously declared: "I have never expected to hear a coxcomb ask two hundred guineas for flinging a pot of paint in the public's face!" – whereupon Whistler sued him for libel.

In the famous court case that followed, the artist was asked whether he had really asked such a high price for only two days' work. "No," he replied, "I ask it for the knowledge of a lifetime."

Whistler won his case, and Ruskin subsequently disappeared from the critical arena.

GUINEA Originally a gold coin worth 21 shillings (£1.05), taken out of circulation in 1813. However, professional fees were often quoted in guineas in Britain until the mid twentieth century.

A FEW THOUGHTS ON COLOR

"Unity in painting is produced when a variety of different colours are harmonized together, these colours in all the diversity of many designs show the parts of the figures distinct, the one from the other, as the flesh from the hair, and one garment different in colour from another. When these colours are laid on flashing and vivid in a disagreeable discordance so that they are like stains and loaded with body… the design becomes marred… All pictures… ought to be so blended in their colours that the principal figures in the groups are brought out with the utmost clearness, the draperies of those in front being kept so light that the figures which stand behind are darker than the first, and so little by little as the figures retire inwards, they become also in equal measure gradually lower in tone in the colour both of the flesh tints and of the vestments."

From LIVES OF THE ARTISTS by GIORGIO VASARI, 1568

"If upon a white canvas I jot down some sensations of blue, of green, of red – every new brush stroke diminishes the importance of the preceding ones. Suppose I set out to paint an interior: I have before me a cupboard; it gives me a sensation of bright red – and I put down a red which satisfies me; immediately a relation is established between this red and the white of the canvas. If I put a green near the red, if I paint a yellow floor, there must still be between this green, this yellow and the white of the canvas a relation that will be satisfactory to me… When I have found the relationship of all the tones the result must be a living harmony of tones, a harmony not unlike that of a musical composition."

HENRI MATISSE (1869-1954)

"Generally speaking, colour directly influences the soul. Colour is the keyboard, the eyes are the hammers, the soul is the piano with many strings. The artist is the hand that plays, touching one key or another purposively, to cause vibrations in the soul."

WASSILY KANDINSKY (1866-1944)

TONAL VALUES

Color can be used to create a feeling of depth and to make a painting appear three-dimensional. "Tonal value" refers to the relative depth of different colors. A red and a green may be very dissimilar in color – but if reduced to pure tone, as in a black-and-white photograph, there may be little contrast between them.

The main image in a painting is termed the "figure," and the background is referred to as the "ground." In order to achieve a picture that is easy to "read," with a clear figure-ground relationship, keep the following rules in mind:

- Colors become paler and duller, and objects less defined, as they recede into the background.
- Warm colors, tending towards red, appear to "come forward" – whereas cool colors, tending towards blue, seem to recede.
- Contrasting tonal values help to give a picture depth, making it look as if you could step into it. A light, clearly defined figure against a darker, more muted ground will appear to come forward, as will a dark, strong figure against a paler ground.
- Lack of tonal contrast makes a picture seem flat, so that everything appears to be on the same plane. In other words, nothing seems to come forward or recede. Taken to extremes, this can cause confusion in the figure-ground relationship, making it unclear which is the figure and which the ground. (Indeed, some modern artists have used this ambiguity to great effect – to create images that can be "read" in several ways.)
- The crisper the edge of an object, the more it will stand out from its background – whereas softer edges seem to blend and recede.

HOW COLORS AFFECT EACH OTHER

"A sallow colour makes another which is placed beside it appear the more lively, and melancholy and pallid colours make those near them very cheerful and almost of a certain flaming beauty."
From LIVES OF THE ARTISTS by GIORGIO VASARI, 1568

When working in color, the artist has to bear in mind the effect that one color has on another. Josef Albers (1888-1976), who migrated to the United States from Nazi Germany in 1933, became fascinated with this idea and explored it in depth in *Homage to the Square* – a series of literally hundreds of paintings, each featuring superimposed squares of different colors. Albers showed how colors are never absolute, but appear to change according to their background. A bright red, for example, may appear warm and vibrant next to a dark gray, but the same red may seem dark and dull when placed against a strong yellow – even looking like a totally different color.

Placing complementary colors next to each other can have a particularly electrifying effect. These consist of a primary color (red, yellow, blue) and a secondary color mixed from the other two primaries (orange, green, purple) – so for a dazzling, almost psychedelic, effect, green can be placed next to red, purple next to yellow, and orange next to blue.

"Flesh is never more glowing than when opposed to blue, never more pearly than when compared with red, never ruddier than in the neighbourhood of green, never fairer than when contrasted with black, nor richer or deeper than when opposed to white."
From MATERIALS FOR A HISTORY OF OIL PAINTING
by SIR CHARLES EASTLAKE, 1847

Artists' Material.

53905 Finely Prepared Colors for Artists.

USING SHADOW

"Painters often fall into despair… when they see that their paintings lack the roundness and the liveliness which we find in objects seen in the mirror… but it is impossible for a painting to look as rounded as a mirror image… except if you look at both with one eye only."
LEONARDO DA VINCI (1452-1519)

Using shadow to create a sense of rounded form is one of the oldest illusions in the artist's bag of tricks. To be really convincing, of course, the shadow has to fall in exactly the right place. One method of working this out, used by the great Venetian painter Tintoretto (1518-94) among others, is to make models of the figures in a scene. These can then be set up in their allotted positions, with light falling from a chosen angle, so the artist can see the way the shadows fall.

"If, by chance, when you are drawing or copying in chapels, or painting in other adverse situations, you happen not to be able to get the light off your hand, or the way you want it, proceed to give the relief to your figures… according to the arrangement of the windows which you find in these places, for they have to give you the lighting. And so, following the lighting, whichever side it comes from, apply your relief and shadow, according to this system… and make it your careful duty to analyse it, and follow it through, because, if it failed in this respect, your work would be lacking in relief, and would come out a shallow thing, of little mastery."
From IL LIBRO DELL'ARTE by CENNINO CENNINI, c. 1435

FINDING THE FORMULAE

"I would say to a person who thinks he wants to paint, Go and look at the way a bird flies, a man walks, the sea moves. There are certain laws, certain formulae. You have to know them. They are nature's laws and you have to follow them just as nature follows them. You find the laws and you fill them in in your pictures and you discover that they are the same laws as in the old pictures. You don't create the formulae... You see them."

JOHN MARIN (1870-1953)

FRAMING A COMPOSITION

Many artists use a home-made frame to help concentrate the eye while working on a drawing or painting. You can make a frame by simply taping together four strips of card or paper. So as to provide contrast, the strips should be a darker color than the picture.

When working on a drawing or colored sketch, lay the frame over the work and move it around to decide the best composition. You will be able to see where the images "sit" best within the frame and where the picture should be cropped. If you decide to make the picture wider or narrower, the shape of the frame, can be adjusted. With a larger work, a frame is useful for concentrating attention on a section – so your eye is not distracted by elements elsewhere in the picture.

"I use a rectangular frame to see the image... I cut down the scale of the canvas by drawing in these rectangles which concentrate the image down."

FRANCIS BACON, 1963

LIGHT SOURCES

Quality and quantity of light is of prime importance to the artist, and natural daylight is still unsurpassed as a light source. Natural light can, however, be unpredictable – and changes in its strength can alter colors and shadows, so it is sometimes necessary to control or modify it for the sake of continuity. Also, throughout history, artists have had to find ways of improvising in the absence of natural light.

DIFFUSED LIGHT

Before glazed windows were the norm, artists covered their window openings with waxed linen or oiled paper, stretched on a frame. This had the effect of diffusing the light coming in and making it less variable. Rembrandt (1606-69) used a blind that could be raised or lowered over the window to control the light, and his studio in Amsterdam had shutters that could be similarly opened or closed. The modern painter Georges Braque (1882-1963) whitewashed the south-facing windows of his studio and then covered them with linen blinds. According to Cennino Cennini, you should "arrange to have the light diffused when you are drawing; and have the sun fall on your left side."

A NORTH LIGHT

In the northern hemisphere most artists prefer to work in light coming from a northerly direction, since it is not so changeable as direct sunlight. Nicholas Hillyarde (1547-1619) described where in the artist's studio the "cleare story" window should be placed:

Pencil Holders.

15483 "Practical" Pencil Holder.

"Conserning the light and place wher yo worke in, let yr light be northward, somewhat toward the east which commonly is without sune, Shininge in. One only light great and faire let it be, and without impeachment, or reflections, of walls, or trees."

CANDLELIGHT

Before the advent of gas and electric lighting, artists wishing to work after sundown had to resort to the expensive practice of using candles. The glowing golds and deep shadows of candlelight fostered the fashion for chiaroscuro (literally "light-dark"). In chiaroscuro, dramatic contrasts of highlights and shadow are created by light coming from a single source. Caravaggio (1573-1610) and Rembrandt are among the greatest exponents of this style of painting.

THE GLASS GLOBE

To increase the power of candlelight, a device was developed consisting of a glass globe filled with water, that could be suspended in front of a candle. The reflective quality of the water would magnify the rays of the flame to produce what one seventeenth-century writer picturesquely described as "a glorious light with a Candle like the Sun Shine."

A PLACE TO PAINT

Many artists have not had the luxury or even the need of a conventional studio, and some have managed to paint in the most unlikely places. During her time in Mexico, Georgia O'Keeffe devised a mobile studio – in the shape of her Model 'A' Ford. When she wanted to paint, she would remove the front passenger seat then unbolt and swivel the driver's seat round to face the back seat, in which she would prop her canvas. The vehicle's generous windows allowed in plenty of light, and the height of the roof enabled her to squeeze in canvases up to 40in tall.

ONLY HALF A FACE

According to John Ruskin, the artist George Catlin had some difficulty with a group of native Americans who "misinterpreted" the use of shadow in a portrait he was painting of one of them:

"The eye of a Red Indian, keen enough to find the trace of his enemy or his prey, even in the unnatural turn of a trodden leaf, is yet so blunt to the impressions of shade, that Mr. Catlin mentions his once having been in great danger from having painted a portrait with the face in half light, which the untutored observers imagined and affirmed to be the painting of half a face."

FORESHORTENING

Foreshortening is a means of drawing or painting a limb or other object so that it appears to be projecting out from the picture towards the viewer.

"Our artists have had the greatest skill in foreshortening figures, that is, in making them appear larger than they really are; a foreshortening being to us a thing drawn in shortened view, which seeming to the eye to project forward has not the length or height that it appears to have; however, the mass, outlines, shadows, and lights make it seem to come forward and for this reason it is called foreshortened. Never was there painter or draughtsman that did better work of this sort than our Michelangelo Buonarroti ... Of these foreshortenings the moderns have given us some examples which are to the point and difficult enough, as for instance in a vault the figures look upwards, are foreshortened and retire. We call these foreshortenings 'al di sotto in su' [up from below], and they have such force that they pierce the vaults."

From LIVES OF THE ARTISTS
by GIORGIO VASARI, 1568

THE PROBLEMS OF PERSPECTIVE

*"He [Uccello] left a daughter, who had some knowledge
of drawing, and a wife who told people that Paolo
used to stay up all night in his study, trying to work out
the vanishing points of his perspective, and that when
she called him to come to bed he would say: 'Oh, what
a lovely thing this perspective is!' "*
From LIVES OF THE ARTISTS by GIORGIO VASARI, 1568

Perspective is a set of mathematical laws that governs
the way in which objects appear to become smaller, or
progressively narrower, as they get further away.
Although artists of earlier times were familiar with
foreshortening and knew how to create an illusion of
depth, the principles of perspective were not known
until the Italian Renaissance – when they were
discovered by the Florentine architect Filippo
Brunelleschi (1377-1446). A perspective drawing is
based on an invisible network of lines that determine
the size and shape of the objects in the drawing.
When working out the correct perspective of the
different objects, it is helpful to bear in mind the
following rules:

• The artist's eye level, or "horizon line," is the level
from which the artist is looking. This may be high
(looking down) or low (looking up), or somewhere
in between.
• All the invisible perspective lines converge towards
the horizon line. Lines below a high horizon line
will slant steeply upwards; lines above a low one
will slant steeply down.
• The point at which the perspective lines intersect
with the horizon line is known as the "vanishing
point." There may be more than one vanishing
point in a picture.
• Perspective lines are never parallel. They converge
as the object recedes – rather like the outlines of a
railway track disappearing into the distance.
• The closer the viewer is to an object, the more
sharply angled its perspective will be.

THE BEAUTY OF PERSPECTIVE

"It is enough to say that perspectives are beautiful in so far as they appear correct when looked at, and diminish as they retire from the eye, and when they are composed of a varied and beautiful scheme of buildings. The painter must take care, too, to make them diminish in proportion by means of delicate gradations of colour that presuppose in the artist correct discretion and good judgement. The need of this is shown in the difficulty of the many confused lines gathered from the plan, the profile, and the intersection; but when covered with colour everything becomes clear, and in consequence the artist gains a reputation for skill and understanding and ingenuity in his art."

From LIVES OF THE ARTISTS by GIORGIO VASARI, 1568

ANAMORPHISMS

Once they had fully grasped the laws of perspective, artists began to have fun with them and invented a new piece of visual trickery – the anamorphism. This was a distorted image that only became recognizable when viewed from a certain angle (rather like certain computer graphics). One famous anamorphism is the strange shape in the foreground of Holbein's *The Ambassadors* – which turns out to be a skull when you look at it from the side. Anamorphisms became increasingly complicated until, in the seventeenth and eighteenth centuries, they could only be understood when viewed in special distorting mirrors.

A HANDY DEVICE

The drawing frame was invaluable both for fore-shortening and rendering perspective, as it enabled the artist to break down what he or she saw into more manageable units. The device consisted of a wooden frame divided into a network of squares, which was placed in front of the subject. Looking through the frame, the artist could analyse the lines and angles in each little square and transpose them to paper divided into squares. It was important that the distance between the subject and the frame and the distance between the frame and the artist should not be altered, otherwise the outlines in the small squares would change.

"Take a Square Frame of Wood about one foot large, and on this make a little grate [network] of Threads, so that crossing one another they may fall into perfect Squares about a Dozen at least, then place [it] between your Eye and the Object, and by this grate imitate upon your Table [drawing surface] the true Posture it keeps, and this will prevent you from running into Errors. The more Work is to be [fore]shortened the smaller are to be the Squares."

From THE ART OF PAINTING AFTER THE ITALIAN MANNER
by JOHN ELSUM, 1704

MIRROR IMAGE

After working long and hard at a painting, often the artist feels stale – and this can lead to spoiling the picture as a result of overworking it. If you feel no longer able to judge a painting objectively, you may find that looking at it in a mirror makes it easier to assess how much further work is needed – since the mirror image provides a fresh point of view.

THE FLOWERING OF A PERSONAL STYLE

One of the most frustrating things for the budding artist can be the lack of a distinctive individual style. According to Cennino Cennini, the way to foster your own personal style is to select one of the great masters (but one only) and diligently copy the best of his work. In the following passage, art is portrayed as a garden of flowers and thorns:

"And, as you go on from day to day, it will be against nature if you do not get some grasp of his style and of his spirit. For if you undertake to copy after one master today and after another one tomorrow, you will not acquire the style of either one or the other, and you will inevitably, through enthusiasm, become capricious, because each style will be distracting your mind... If you follow the course of one man through constant practice, your intelligence would have to be crude indeed for you not to get some nourishment from it. Then you will find, if nature has granted you any imagination at all, that you will eventually acquire a style individual to yourself, and it cannot help being good; because your hand and your mind, being always accustomed to gather flowers, would ill know how to pluck thorns."

From IL LIBRO DELL'ARTE by CENNINO CENNINI, c. 1435

Painting.

CHAPTER SIX:
VISIONS AND REALITY

"I SAW THE ANGEL IN THE MARBLE
AND I JUST CHISELLED UNTIL I SET HIM FREE."
MICHELANGELO BUONARROTI (1475-1564)

OBSERVATIONS ON ART

"Should we not say that we make a house by the art of building, and by the art of painting we make another house, a sort of man-made dream produced for those who are awake?"
PLATO (c. 427-347 B.C.)

"To become truly immortal a work of art must escape all human limits: logic and common sense will only interfere. But once these barriers are broken it will enter the regions of childhood vision and dream."
GIORGIO DE CHIRICO (1888-1978)

"Some advice: do not paint too much after nature. Art is an abstraction; derive this abstraction from nature while dreaming before it, and think more of the creation which will result than of nature. Creating like our Divine Master is the only way of rising toward God."
PAUL GAUGUIN (1848-1903)

"Have you ever seen an inch worm crawl up a leaf or twig, and then clinging to the very end, revolve in the air, feeling for something to reach something? That's like me. I am trying to find something out there beyond the place on which I have a footing."
ALBERT PINKHAM RYDER (1847-1917)

"Every artist dips his brush into his own soul, and paints his own nature into his pictures."
HENRY WARD BEECHER (1813-87)

"[Art is] a corner of nature seen through a temperament."
ÉMILE ZOLA (1840-1902)

"You do not see with the lens of the eye. You see through that, and by means of that, but you see with the soul of the eye."
JOHN RUSKIN (1819-1900)

ART OR CRAFT?

Our contemporary view of the artist as an inspired, perhaps tortured, soul has not always held sway. In centuries gone by, the artist was seen much more as a skilled craftsperson, who had to learn the techniques of the trade in the same way as any other apprentice. No one in Renaissance Italy would have been particularly surprised to hear that some of its greatest geniuses had been involved in comparatively menial work: Michelangelo carved a snowman for Piero de Medici, Piero della Francesca painted a processional banner, Uccello painted furniture and clock faces, and the sculptor Donatello carved coats of arms for chimneypieces and house fronts.

"It is not without the impulse of a lofty spirit that some are moved to enter this profession, attractive to them through natural enthusiasm. Their intellect will take delight in drawing, provided their nature attracts them to it of themselves, without any master's guidance, out of loftiness of spirit. And then, through this delight, they come to want to find a master; and they bind themselves to him with respect for authority, undergoing an apprenticeship in order to achieve perfection in all this... Begin to submit yourself to the direction of a master for instruction as early as you can; and do not leave the master until you have to."

From IL LIBRO DELL'ARTE by CENNINO CENNINI, c.1435

A GENTLEMAN'S PROFESSION

"Pliny tells us, That… throughout all Greece it was ordained, That… Art itself should be ranged in the first degree of Liberal Sciences. Certain it is, That in former times it was had in that honour, that none but Gentlemen and free-born might meddle with it; as for Slaves, by a strict and perpetual Edict they were excluded from the benefit of this mystery."

From THE WONDERS OF THE LITTLE WORLD by NATH WANLEY, 1678

THE WOMAN ARTIST

Throughout the history of art, women have rarely received the same acclaim as men. When, in 1916, some drawings by Georgia O'Keeffe (1887-1986) were shown to the photographer Alfred Stieglitz (whom she later married), he exclaimed "At last, a woman on paper!" O'Keeffe herself was keenly aware of the lack of recognized women artists and said she frequently questioned the sources of her own work, as she wanted to be free of the influences of male artists, so her work would be not only totally personal but totally female.

As a mother as well an artist, the British sculptor Barbara Hepworth (1903-75) had rather more practical concerns. The traditional mothering role, she said, did not detract from her art but, rather, enriched her life – the trick being to do at least half an hour's work each day, just to keep one's creativity flowing.

SUFFERING FOR ART

"The true artist will let his wife starve, his children go barefoot, his mother drudge for his living at seventy, sooner than work at anything but his art."

From MAN AND SUPERMAN by GEORGE BERNARD SHAW, 1928

The image of the artist starving in a garret has more than a grain of truth in it. Indeed, many of the world's great painters at some time renounced the comforts of the conventional world and suffered for their art.

PAUL GAUGUIN

Gauguin's story is one of the most famous of such tales. With a successful career in stockbroking ahead of him, he nevertheless decided in 1883 to leave the security of his job and devote all his time to painting. In 1891, he turned his back on all he knew and went to live in Tahiti. Increasingly dogged by debts and ill health, Gauguin died destitute, of a burst blood vessel, when he was fifty-five years old.

HENRI MATISSE

Inspired by the example of Gauguin, Henri Matisse decided to abandon his job as a notary's clerk to pursue his art. He and his wife, who ran a dress shop, enjoyed few luxuries: their home was a tiny room, just the width of a bed.

PABLO PICASSO

In 1904 a 23-year-old Spanish painter named Pablo Picasso settled in Paris, where he rented a studio in the Bateau-Lavoir for 15 francs a month. The dilapidated building, which housed nearly thirty studios, had one tap, no gas or electricity, and stank of cats' urine. The area was so dangerous that Picasso was never able to go out at night unless he was armed.

JUAN GRIS

With the help of his sister – who was also an artist – at the age of nineteen Juan Gris sold all his belongings, including his bed and mattress, to raise the 16 francs needed for a train ticket to Paris. After his arrival, like Picasso he rented a studio in the Bateau-Lavoir, where he covered the walls of his room with rows of scrawled figures – a record of what he owed the local grocer, who had agreed to feed him on credit.

REMBRANDT VAN RIJN

Rembrandt's fortunes as a painter fluctuated during his lifetime. Having lost his popularity with the public, when he died in 1669 he left no possessions other than some old clothes and his painting equipment.

A CRUST OF BREAD AND AN EASEL

"The artist needs but a roof, a crust of bread and his easel, and all the rest God gives him in abundance. He must live to paint and not paint to live. He cannot be a good fellow; he is rarely a wealthy man, and upon the potboiler is inscribed the epitaph of his art."
ALBERT PINKHAM RYDER (1847-1917)

THE ARTISTIC TEMPERAMENT

"The Lives of Painters say that Rafael Died of Dissipation. Idleness is one Thing & Dissipation Another. He who has Nothing to Dissipate cannot Dissipate; the Weak Man may be Virtuous Enough, but will Never be an Artist. Painters are noted for being Dissipated & Wild."
WILLIAM BLAKE (1757-1827)

In literature the artist is commonly portrayed as being wild and dissolute, or at least as having little regard for conventional values. It is true that many artists, such as Caravaggio, Stanley Spencer, and Augustus John, have conformed to this Bohemian image.

Others, however, such as Fra Angelico – a celibate Dominican monk and one of the great Italian masters of the fifteenth century – would surely have won the approbation of Cennino Cennini, who warned artists of the perils of immoderate behavior:

"Your life should always be arranged just as if you were studying theology, or philosophy, or other theories, that is to say, eating and drinking moderately, at least twice a day, electing digestible and wholesome dishes, and light wines; saving and sparing your hand, preserving it from such strains as heaving stones [with a] crowbar, and many other things which are bad for your hand, from giving them a chance to weary it. There is another cause which, if you indulge it, can make your hand so unsteady that it will waver more, and flutter far more, than leaves do in the wind, and this is indulging too much in the company of women."
From IL LIBRO DELL'ARTE by CENNINO CENNINI, c.1435

FOR THE LOVE OF ART

Artists were not the only ones who sometimes had to curb their natural passions. Leonardo da Vinci used to tell a story about a religious painting he had done which so strongly affected its owner that he wanted to kiss it – a totally inappropriate response considering its saintly subject matter. But propriety triumphed in the end. "Finally," explained Leonardo, "his conscience prevailed over his sighs and lust…but he had to remove the picture from his house."

THE HAND OF THE PAINTER

The Spanish artist Juan Gris (1887-1927) always patted dogs with his left hand – so that, should he be bitten, his right hand would remain unharmed and he would still be able to lift a paintbrush.

GENIUS

"Genius is one per cent inspiration and ninety-nine per cent perspiration."
THOMAS ALVA EDISON (1847-1931)

The story goes that Augustus John's artistic talent was due to an accident he had when in his teens. According to Virginia Shankland, who wrote the text for one of the "Famous People" cards sold with Brooke Bond tea, John "hit his head on a rock whilst diving, and emerged from the water a genius! He became a magnificent draughtsman; this mastery later spread to painting."

AMBITION

"When I was three, I wanted to be a cook. When I was six I wanted to be Napoleon. Since then my ambition has done nothing but grow."
SALVADOR DALI (1904-89)

"If I didn't start painting, I would have raised chickens."
GRANDMA MOSES (1860-1961)

INSPIRATION

"It is not to be despised, in my opinion, if, after gazing fixedly at the spot on the wall, the coals in the grate, the clouds, the flowing stream, one remembers some of their aspects; and if you look at them carefully you will discover some quite admirable inventions. Of these the genius of the painter may take full advantage, to compose battles of animals and of men, of landscapes or monsters, of devils and other fantastic things."
LEONARDO DA VINCI (1452-1519)

"If the emotions are sometimes so strong that one works without knowing one works... then one must remember that it has not always been so... there will again be heavy days, empty of inspiration."
VINCENT VAN GOGH (1853-90)

GREED

"The first great care of one who seeks to obtain eminence in painting is to acquire the fame and renown of the ancients. It is useful to remember that avarice is always the enemy of virtue. I have seen many in the first flower of learning suddenly sink to money-making."
From ON PAINTING by LEON BAPTISTA ALBERTI, 1436

SUCCESS

"There is no way to success in art but to take off your coat, grind paint, and work like a digger on the railroad, all day and every day."

From CONDUCT OF LIFE: POWER by RALPH WALDO EMERSON (1803-82)

HONORS

Ignored by the Establishment when at the height of his powers and only recognized when old, the painter Thomas Eakins eventually had his revenge. In 1904 the Pennsylvania Academy awarded him a gold medal. He arrived to collect it with a friend – both of them wearing cycling clothes. Accusing the Academy of a "heap of impudence" in daring to give him a medal, he at once cycled to the Philadelphia mint where he scornfully turned the trophy into cash.

THE DALI TEST

In 1987 Salvador Dali produced a league table of artists, assigning each of them marks out of 20 for inspiration, technique, design, originality, and genius. Vermeer, Raphael, and Velázquez scored high, gaining 20 for genius and an overall average of 19.9, 19.6, and 19.2 respectively. Ingres, Manet, and Mondrian were less fortunate: each scored nought for genius, the latter coming right at the bottom of the class with a miserable average of 0.7. Dali himself didn't fare too badly, with 19 for genius and an overall score of 16.4.

CRITICAL REACTIONS

"Do not be an art critic, but paint
– therein lies salvation."
PAUL CÉZANNE, 1904

Tintoretto advised a sort of "love-at-first-sight" policy for judging a painting: a successful work would satisfy the eye at first glance. He also recommended waiting for some time before going to see any painting on public display, for by then "all the darts would have been thrown" and one would be able to make one's own assessment more freely.

Leonardo urged artists to listen to hostile criticism – and also to be wary of praise motivated by jealousy or the desire to flatter:

"There is nothing that deceives us more than our own judgment when used to give an opinion on our own works. It is sound in judging the works of our enemies but not that of our friends, for hate and love are two of the most powerfully motivating factors found among living things. Thus, O painter, be eager to hear no less willingly what your enemies say about your work than what your friends say. Hate is more powerful than love, for hate ruins and destroys love... There is a third kind of judgment, which is moved by jealousy and gives rise to flattery, praising the early stage of a good work so that the lie may blind the painter."

THE EXHIBITION

By the time the Mexican artist Frida Kahlo (1907-54) had her first one-woman show, her long history of ill-health had taken its toll. Nevertheless, despite being seriously ill, she was determined not to miss the opening. She arranged for her four-poster bed to be set up in the gallery and then, timing her arrival for maximum effect, drove up in an ambulance with the siren wailing. Carried in on a stretcher, she was placed on the bed, from which she held court to the excited throng.

THE UNFINISHED COMMISSION

Even the wealthiest and most powerful patrons sometimes have trouble getting work out of artists – as is illustrated by the following letter from an exasperated Isabella d'Este – one of the most famous Renaissance patrons – to a former Venetian ambassador. Had the Duchess had greater foresight, perhaps she would have included a penalty clause in her original commission:

"Three years ago I gave Giovanni Bellini, the painter, 25 ducats as part payment of a subject which he promised to do for my studio. Afterwards, since he declined to paint this Storia, he agreed to execute a Nativity of Our Lord for the said sum ... The master has never kept any of his promises, and does not, it is plain, intend to keep them. As there is no one in Venice whom we trust more than Your Magnificence, we have thought it best to ask you to desire Bellini to return our 25 ducats, without accepting either excuses or promises, for we will have no more of his work."

When Alfonso D'Este experienced similar problems with Titian, he wrote to his agent hinting at the dire consequences of failure to meet a ducal deadline:

"We thought that Titian, the painter, would some day finish our picture; but he seems to take no account of us whatsoever. We therefore instruct you to tell him instantly, that we are surprised that he should not have finished our picture; that he must finish it under all circumstances or incur our great displeasure."

THINKING TIME

When accused of tardiness, an artist's response is often that although there may not be much visible evidence of progress, a great deal of vital unseen thinking has quietly been going on. Leonardo was certainly of this opinion, saying that geniuses sometimes achieve most when they seem to be doing least.

THE TRUE PICTURE

In 1855 George Innes accepted a commission from the president of a railroad company to paint a picture of the Lackawanna Valley, to be used as an advertisement. At the time, there was only one line running into the roundhouse in the valley – but Innes' client insisted that the artist painted four or five lines to make the company's operations seem more extensive than they actually were. Innes protested, but eventually gave in as he had a family to support. He salved his conscience, however, by obscuring the spurious lines with puffs of smoke from a passing locomotive.

SMALL IS BEAUTIFUL

"There is a right physical size for every idea. A carving might be several times over life size and yet be petty and small in feeling – and a small carving only a few inches in height can give the feeling of huge size and monumental grandeur, because the vision behind it is big. Example, Michelangelo's drawings or a Masaccio madonna – and the Albert Memorial."

HENRY MOORE (1898-1986)

THE ALBERT MEMORIAL
An elaborate monument in Kensington Gardens, London, built in memory of Prince Albert, consort of Queen Victoria.

THE UNWANTED COMMISSION

A conspiracy that backfired gave the Western world one of its greatest pieces of art. The architect Bramante – a friend and relative of Michelangelo's great rival, Raphael – hatched a plot to remove the sculptor from the Pope's favor. Knowing that Michelangelo was an inexperienced fresco painter, he persuaded Pope Julius II to halt the sculptor's work on the papal tomb – continuing with it would be a bad omen, he said, an invitation to death – and to transfer him to painting the vaulted ceiling of the Sistine Chapel. Michelangelo tried everything he could think of to avoid the commission, even suggesting that Raphael would be a more suitable choice. However, the Pope insisted.

Michelangelo sought the help of some Florentine fresco painters, whose technique he hoped to observe – but, disappointed with their efforts, he dismissed them and took on the job himself, working single-handed except for the aid of a color mixer.

When the ceiling was only half-completed, the importunate Pope flung the chapel open to public view. On seeing Michelangelo's genius, Raphael is said to have changed his style – while Bramante tried, unsuccessfully, to persuade the Pope to let Raphael complete the ceiling.

Michelangelo was allowed to complete the work – although not to his own satisfaction, thanks to His Holiness's impatience. The chapel was finally opened on All Saints' Day, 1512, when the Pope came to sing Mass there – and the ceiling met with unanimous enthusiasm. Michelangelo had taken only twenty months of intermittent and disrupted work, between 1508 and 1512, to complete the masterpiece.

WASSILY KANDINSKY: *"The contact between the acute angle of a triangle and a circle has no less effect than that of God's finger touching Adam's in Michelangelo."*

KEITH VAUGHAN: *"Not to me, boy."*

FASHIONS IN ART

"How strongly do new paintings usually appeal to us at first for the beauty and variety of their colours, and yet it is the old and rough picture that holds our attention."
MARCUS TULLIUS CICERO (106-43 B.C.)

We are accustomed to seeing brightly colored canvases, but it was not always so; the fashion was once for much more subdued works. According to Pliny, the ancient Greek painter Apelles (late fourth century B.C.) used to tone down his pigments with a dark glazing "so that the brightness of colors should not hurt the eyes." This was similar to the nineteenth-century practice of coating oil paintings with a yellow varnish in order to give them the fashionable "gallery tone."

The English landscape painter John Constable, whose palette must have seemed almost garish to nineteenth-century eyes, commented bitterly on hearing of a prospective buyer for one of his works: "Had I not better grime it down with slime and soot, as he is a connoisseur, and perhaps prefers filth and dirt to freshness and beauty?"

WHAT OUR ARTIST HAS TO PUT UP WITH.
"It's very odd—but I can't get rid of my Pictures. The House is full of them!"
"Can't you get your Grocer to give 'em away with a Pound of Tea, or something?"

ART FOR THE PEOPLE

"Art in America is like patent medicine or a vacuum cleaner. It can hope for no success until ninety million people know what it is."
MARSDEN HARTLEY (1877-1943)

AN ARTIST'S END

The painter Frida Kahlo's exit from this world was no less dramatic than her life. At her cremation, as the coffin glided forward, the heat of the flames suddenly made the body sit upright in a final and grotesque farewell. The fire took four hours to do its work, during which time the mourners sang and her husband, the muralist Diego Rivera, dug his nails into his palms so hard that they drew blood. When the doors of the furnace reopened and Frida's charred remains were revealed, her ashes still retained the shape of her skeleton. Seeing this, Rivera quietly reached into his pocket, took out a sketchbook, and calmly made a drawing of his wife's powdery silhouette.

FINAL JUDGMENTS

"He died… as badly as he had lived."
GIOVANNI BAGLIONE – ON THE DEATH OF CARAVAGGIO IN 1610

"Nothing of interest happened here other than the sudden death of a sad personage named Gauguin, a famous artist, enemy of God and of all that is honest."
A LOCAL BISHOP ON THE DEATH OF GAUGUIN – IN TAHITI IN 1903

"His regret at losing life was principally the regret of leaving his art."
SIR JOSHUA REYNOLDS – ON THE DEATH OF GAINSBOROUGH IN 1788

"I am old and ill, and I have sworn… to die painting."
PAUL CÉZANNE – A MONTH BEFORE HIS DEATH IN 1906

"He was thirty-seven when he died; and we can be sure that just as he embellished the world with his talent so his soul now adorns heaven itself… As he lay dead in the hall where he had been working, they placed at his head the picture of the Transfiguration which he had done for Cardinal de Medici; and the sight of this living work of art along with his dead body made the hearts of everyone who saw it burst with sorrow."
GIORGIO VASARI – ON THE DEATH OF RAPHAEL IN 1520